Knowing Stephanie

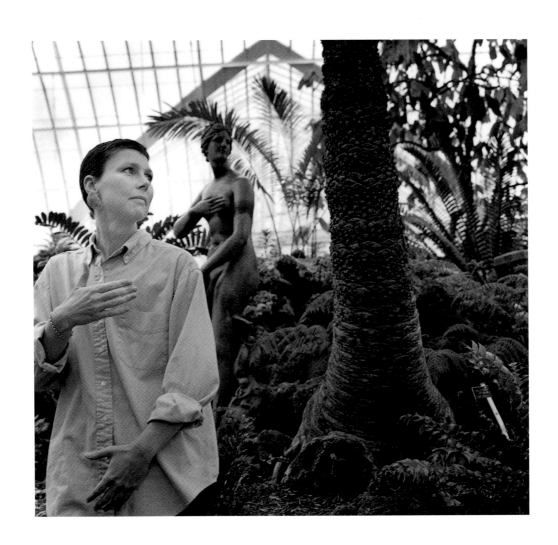

Knowing Stephanie

Photographs by Charlee Brodsky, Words by Stephanie Byram

with an Essay by Jennifer Matesa

University of Pittsburgh Press

A John D. S. and Aida C. Truxall Book

Published by the University of Pittsburgh Press, Pittsburgh, Pa., 15260

Copyright © 2003, Charlee Brodsky, Stephanie Byram, and Jennifer Matesa

Manufactured in the United States of America

Printed on acid-free paper

10 9 8 7 6 5 4 3 2 1

ISBN 0-8229-4212-7

To all people whose lives have been changed by events they never foresaw.

— Stephanie

In memory of my mother-in-law, Ilene Kamlet, who died of breast cancer. She gave me my husband and so much more . . .

— Charlee

For my sister, Judy Klatt, and my nieces, Laura Elizabeth and Elaine Marie: May you always live well.

— Jennifer

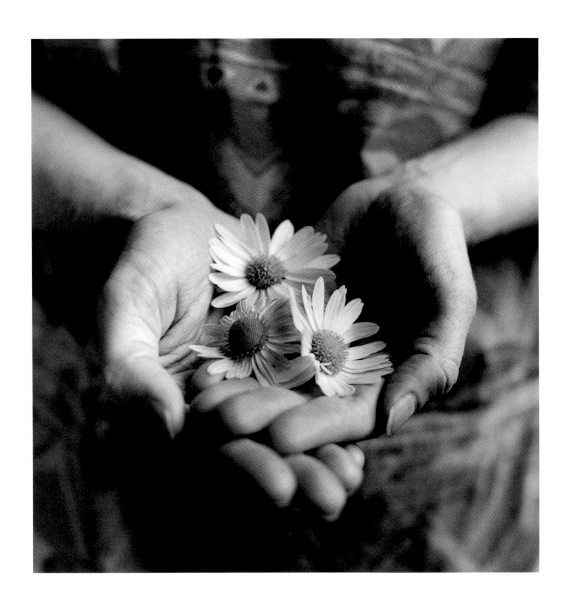

Contents

Stephanie died on Saturday, June 9, 2001. On that day, I was with her in the hospital, as were many of her family and friends. We alternately sat beside her, stroked her arm, softly talked to her, and held her hand. Her breathing was loud and labored and she was in a deep sleep because of her pain medications. It wasn't clear to me if she knew we surrounded her. I want to believe that she did.

I was among the first people that Stephanie met when she came to Pittsburgh to pursue graduate studies at Carnegie Mellon University. My husband headed the department where she was to study, and when she arrived in the city, Mark offered our house as her home base while she looked for an apartment. Neither she nor I knew how our lives would unfold and intertwine then, and how meaningful we would become to each other. Early on, Stephanie and I became friends. At times we ran together, meeting early in the mornings so that I could be showered, dressed, and in the classroom teaching by 9:00 A.M. She was always the better runner of the two of us. We also shared a love of gardening and the outdoors. We bought plants together in the spring for our gardens, although our color palettes differed—Stephanie liked strong reds and I tended toward softer pastels.

When Stephanie was diagnosed with aggressive breast cancer, it was a great blow to all of her friends and colleagues at Carnegie Mellon. The irony was that she was in terrific shape in terms of her cardiovascular fitness. It was unimaginable that she was harboring an insidious, life-sucking disease. She had recently won, with her team of two other graduate students, the Carnegie Mellon triathlon. She looked in top form, athletic and fit, and she was only thirty. Recovery seemed slow after her mastectomies. She was hit with a hard blow, both emotionally and physically.

Almost eight months after her diagnosis, while at a department party during the holidays, Stephanie asked if I would make a photograph of her.

She was preparing a press packet to advertise her quest to be the first person—not the first survivor, as she once corrected me—to run in every Race for the Cure. By participating in the races, she hoped to raise money for breast cancer research and people's awareness of the disease. She also knew that running helped her to heal. I was happy to oblige Stephanie, and we set a date for the photo session. We didn't make the PR photograph on that day. But we did start our project. Stephanie asked if I wanted to see her scars. I said yes. She lifted her shirt. It occurred to me that we could do a project together—my photographs, her voice.

Our casual friendship developed into something more when we started our photo project. We shared parts of ourselves, from intimate, deep-down private emotions to the collegial give and take of a professional relationship. We were making something together, we didn't know what at the time, but we did know that it had my images and her words, and we knew we owned it jointly. It made us close. Stephanie trusted me to make her image, and I responded by wanting to make images that represented who I saw—a radiant person who I respected and grew to love.

Our working relationship consisted of choosing where and when to photograph, sharing contact sheets from the shoots, deciding which images to include, seeing how her words worked with the images, giving talks to various audiences—in sum, spending much time together making and disseminating the work. We exhibited the work locally and nationally, and with the help of others, we developed two Web sites, published the work as articles in newspapers, magazines, and journals, and created a half-hour video with a talented film crew. As far as I can recall, Stephanie and I never had a serious difference of opinion but we occasionally disagreed. Tastes differ. I remember a photograph, early on in our project, which she adored. I did not. That photograph never made its way into our project, but I did print it seven times for her relatives that Christmas.

Our project, I learned obliquely when we were meeting with a magazine editor, held great meaning for her. Until then, I thought of our photo sessions as something on her calendar, just another photo shoot. I was certainly invested but I didn't know how far she was. In conversation with the editor, she said that one of our photographs, the one we called Venus, was a "turning point" for her. This photograph was pivotal in her life with cancer. It allowed her to see her body as whole and beautiful, not maimed. Because of this photograph, I believe Stephanie was able to visualize herself differently and therefore was able to live differently. She was able to transform her profound disappointment with

the cards she was dealt into a life that was about living. Only once, on a walk, did Stephanie tell me what our project meant to her. We rarely told each other the big things, like how important we were to each other. We just knew that we were.

Much happened during the last day I spent with Stephanie and most of it is vivid in my mind. I was physically very close to Stephanie in the hospital and at her home. I sat by her, with her family and friends, while she was dying and after she died. I studied her closely, her face and hands especially. Her features were familiar—I had photographed her ears, nose, mouth . . . her whole body many times during the eight years of our project. But, ironically, her fragile, slight, recumbent body had a riveting presence on this day. I knew that she would leave us soon, and my eyes soaked her in. While looking at her, I saw many pictures and compositions. Many arrangements of her features through my camera's viewfinder would have been intensely melancholy and moving photographs.

That evening a good friend asked me if I had thought about photographing Stephanie while in the hospital and later at her home. I took time to think of my reply, to form it into words and to make it understandable to myself and to my friend. When looking at Stephanie, I did see photographs, as I often "see" photographs when my eyes are open. But I never thought of bringing out my camera. Stephanie and I had always decided together when, where, and how to make our photographs—but while she was dying, she could not let me know what she wanted. Stephanie had been my subject but she was also my collaborator. In this, our last experience together, I took her silence to be an invitation to leave my camera aside and to be present with her. I'm glad that there wasn't a camera between us. My last day with Stephanie is with me and is more real than the photographs that I made of her. Even though photographs are more tangible, memories that we hold in our minds are etched deeply. Not from a photograph, but from within my being, I see her skin, close up, on that last day, lightly freckled. Her hair is cropped close to her head, an appealing shade of brown and gray, in a perfect shape around the curve of her ears. I don't know if Stephanie would have wanted me to photograph her that day. I made the decision not to on my own.

Charlee Brodsky

Knowing Stephanie

This is me. This image tells a lot about me, but what it doesn't say is that I've had cancer. Just after I turned thirty years old, my right breast began to feel painful and swollen. I couldn't feel a lump. The doctor sent me for a mammogram, but it didn't show a lump either. It did show tiny specks called calcifications. There were so many that the x-rays looked like a little galaxy inside each breast. The surgeon said he feared I had "highly aggressive, highly malignant breast cancer." He was right.

On May 24, 1993, I had surgery to remove both breasts. Because my cancer had advanced by the time it was discovered, the doctors gave me a 50 percent chance of surviving five years and a 40 percent chance of surviving ten years.

Diagnosis

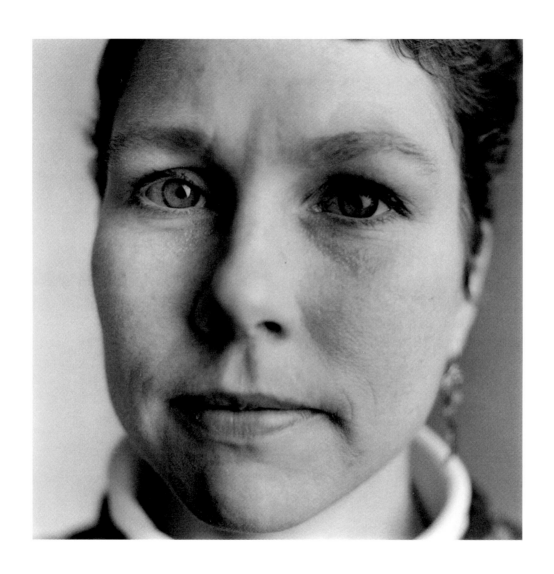

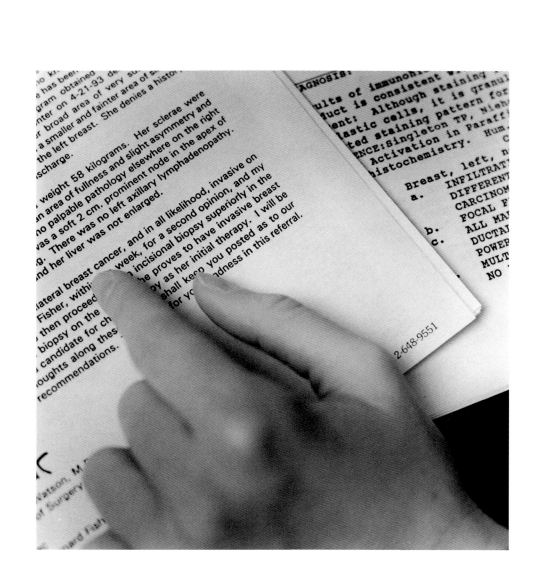

17

Loss, Fear, Sorrow

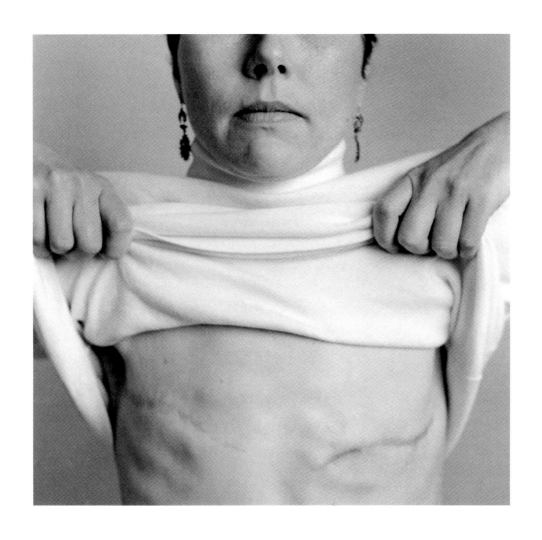

Cancer ravaged my sense of self. My body betrayed me. It could no longer be trusted, especially since I had treated it so well, with a nutritious diet and regular exercise.

Suddenly every body part (and all my assumptions about good health) became suspect. I was no longer whole.

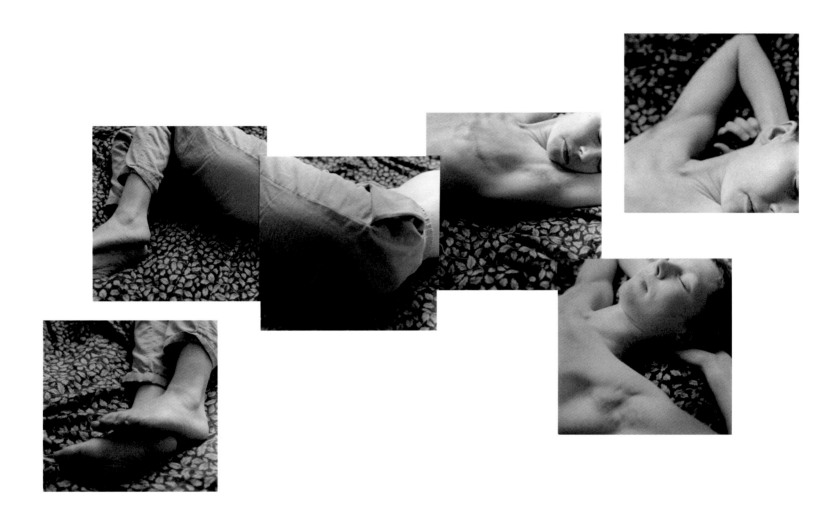

Lost

 Womanhood
 Sexuality
 Motherhood

 Why am I so sad?

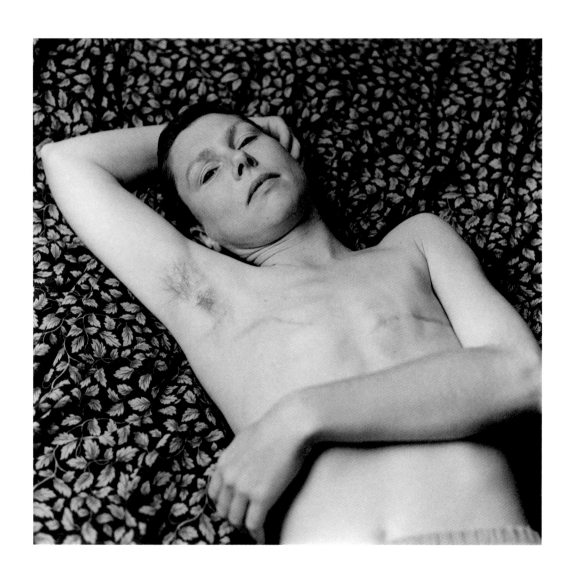

23

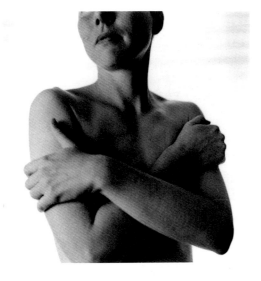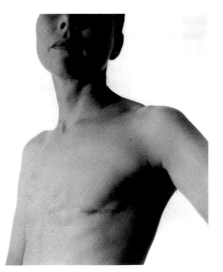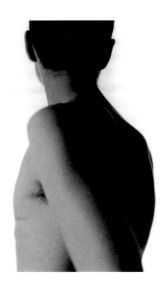

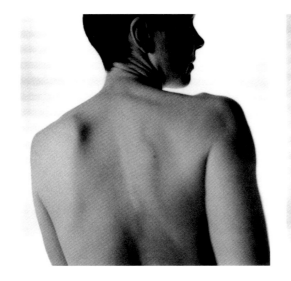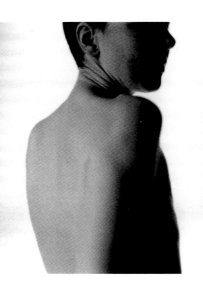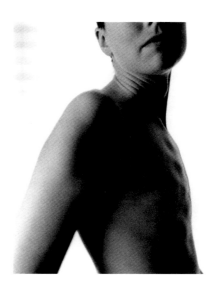

After learning my story, many people glance at my chest almost despite themselves, making me feel embarrassed and self-conscious.

Then we did the "Venus" photo. Like a Michelangelo sculpture with the arms knocked off, I now see my torso as a work of art. Although I'm missing some pieces, I no longer feel disfigured. This image was a turning point for me.

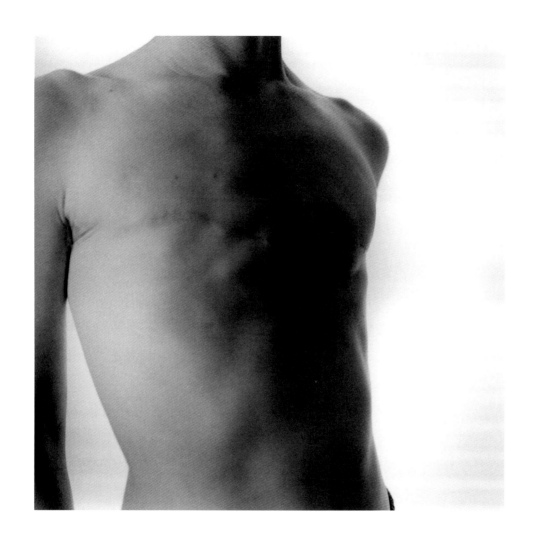

Searching for Balance

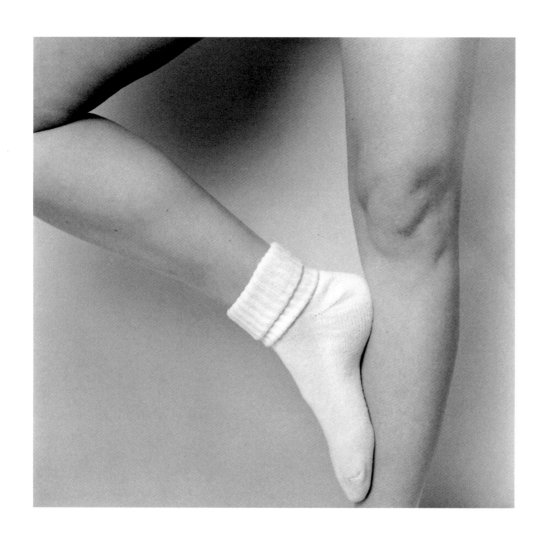

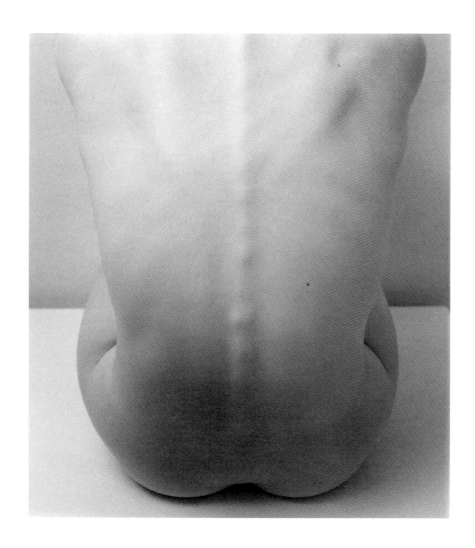

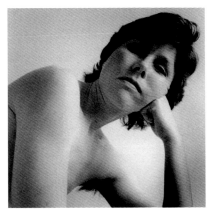
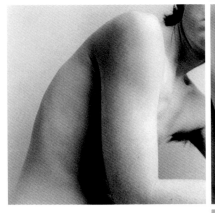
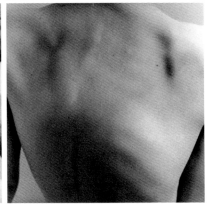
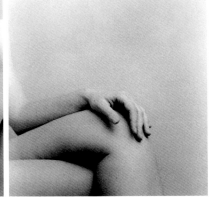
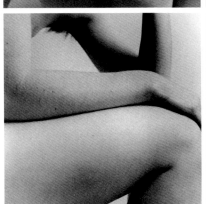
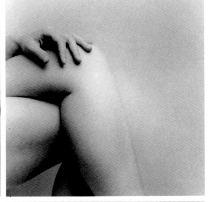

32

My body and soul do not function as separate parts. I pieced together a new self, unified and wonderfully alive.

Reflection has been my salvation.

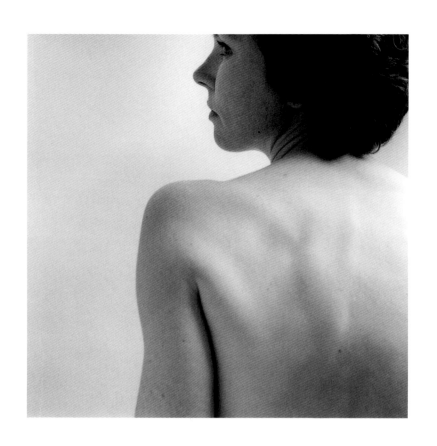

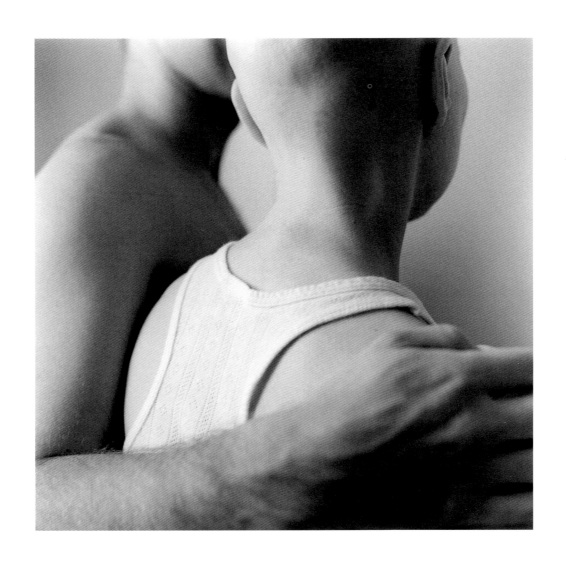

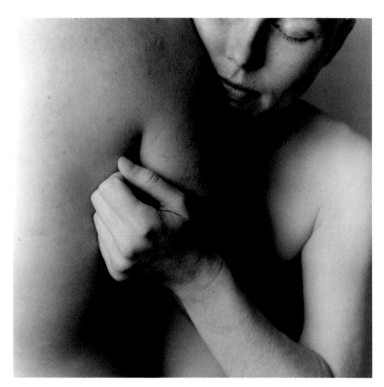
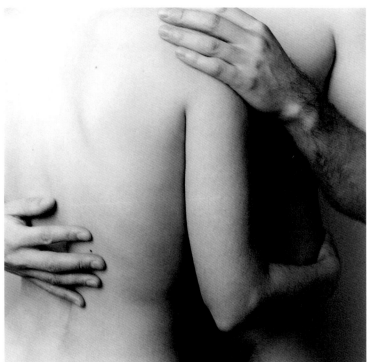

Breasts equal sexuality, at least in our society.

Without breasts, my sexuality unalterably changed. As an unmarried woman, would men still be attracted to me? Would I ever discover a partner for whom my body would be acceptable or enjoyable? My friends assured me that, oh yes, plenty of men would still be interested. Although comforted, my skeptical side thought, "Hmm, we'll see about that."

Self-acceptance happened suddenly. Sitting in a hot tub, I revealed my new body hesitantly to a group of women. No one there had seen anyone with a mastectomy before. To my amazement, no one fainted or looked shocked, no one pitied me. It was a simple meeting of women comfortable with nudity, accepting their bodies and mine. I began to realize how little I had lost.

Later I discovered that I still lusted after the same men who were attractive to me before my diagnosis. Unexpectedly acting on those feelings, I experienced an awakening that liberated me from the stereotypes and fears of owning a "mutilated" body. My flat torso simply didn't matter; the chemistry and the intense passion were the same.

It's ironic, but I realized that my sexuality and self-esteem became more secure after my body changed. My friends were right.

Finding My Place

The numbers shocked me, a 50 percent chance of surviving five years. Until cancer, I lived as if my legacy would emerge from a lifetime of creativity, dedication, collaboration, and hard work. I put off until retirement traveling, environmentalism, and gardening, joys too consuming to fit into two weeks of vacation a year.

Suddenly confronted with my mortality, I needed to create a legacy for now. It dawned on me that the Race for the Cure presented a perfect opportunity to do something healthful for myself, and for others, to show the lively side of survivorship. The next day I called the national Race for the Cure office in Dallas and got a list of thirty-six races around the country. With the first race on January 26, 1994, in West Palm Beach, Florida, I made my debut.

We all find a way to heal.

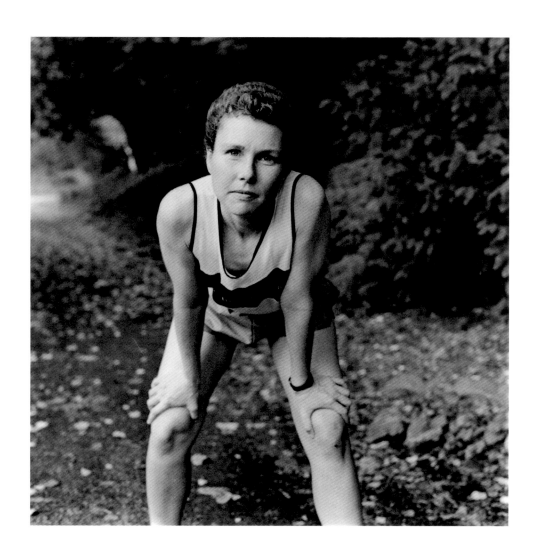

Running against cancer is my quest to run in all of the Susan G. Komen Foundation's Races for the Cure. My goals are to raise one hundred thousand dollars for breast cancer research and to raise awareness of breast cancer. A woman is diagnosed with breast cancer every three minutes and one dies from breast cancer every eleven minutes, on average, in the United States. Men get breast cancer, too, by the way.

So far, twenty-six races down and thirty-one to go!

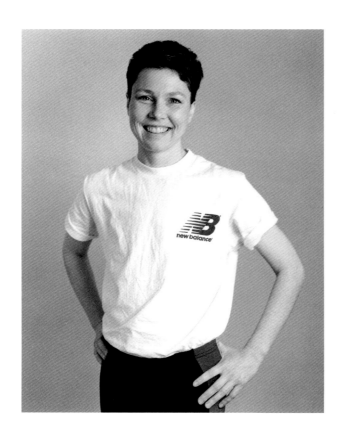

Races already run (time, place)

10/7/95	Amarillo, Texas (25:55, first place*)
9/17/95	New York City (26:48)
9/9/95	Boston, Massachusetts (33:xx)
8/13/95	Kansas City, Kansas (29:03, fifth place*)
6/17/95	Washington, D.C. (28:35)
6/10/95	Columbus, Ohio (25:10, third place*)
5/14/95	Pittsburgh, Pennsylvania (25:32)
5/13/95	New Britain, Connecticut (24:35)
1/21/95	West Palm Beach, Florida (24:15, third place*)
10/29/94	Atlanta, Georgia (24:45, first place*)
10/23/94	San Francisco, California (23:45)**
10/9/94	Nashville, Tennessee (23:55, first place*)
10/8/94	Memphis, Tennessee (24:45, first place*)
10/2/94	Princeton, New Jersey (24:05, first place*)
10/1/94	Baltimore, Maryland (27:27)
9/25/94	Portland, Oregon (23:47, fifth place*)
9/18/94	Cleveland, Ohio (24:45, first place*)
9/10/94	Boston, Massachusetts (24:20, second place*)
7/31/94	Manchester, Vermont (24:46, third place*)
6/26/94	Seattle, Washington (24:05)
6/18/94	Washington, D.C. (¿)
6/4/94	Plano, Texas (29:28)
5/8/94	Minneapolis, Minnesota (24:37)
5/7/94	Peoria, Illinois (29:30)
4/16/94	Indianapolis, Indiana (28:29, second place*)
4/9/94	Detroit, Michigan (25:02, first place*)
3/27/94	Austin, Texas (27:12, first place*)
2/12/94	El Paso, Texas (29:24)
1/29/94	West Palm Beach, Florida (31:19)

*in the Breast Cancer Survivor category

**Personal Best

When told they have a life-threatening illness, some people withdraw into themselves. I, on the other hand, seek connections outside of myself, both physically and spiritually.

Pilar, my dog, offers love, play, and companionship, presenting her soft, gentle spirit to me every day . . . unconditionally.

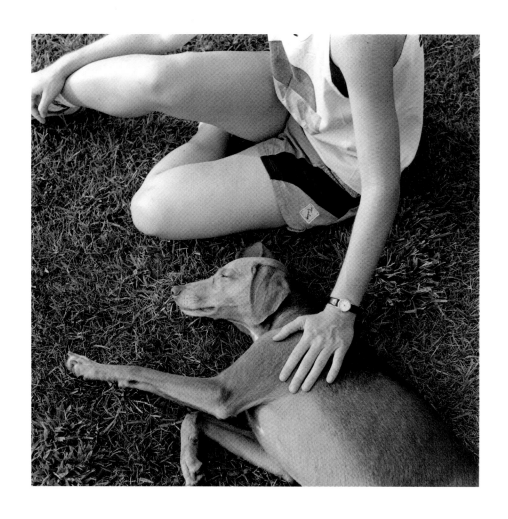

In this image, I see a circle formed by my arm and her leg. It represents the
unspoken interdependencies of nature, between people, plants, earth, animals.
Without each other, our bodies and souls wither and die.

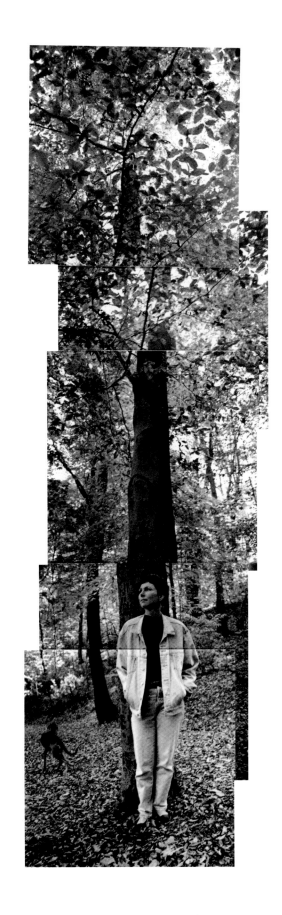

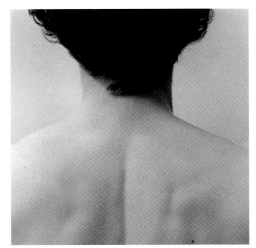 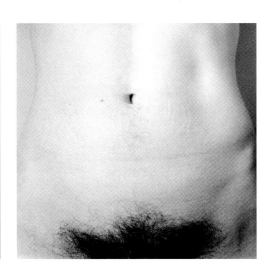

After losing my hair to the cure,
I now relish each and every strand
that has come back.

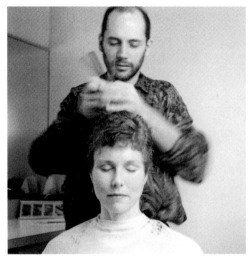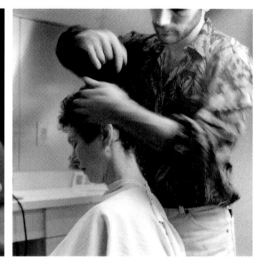

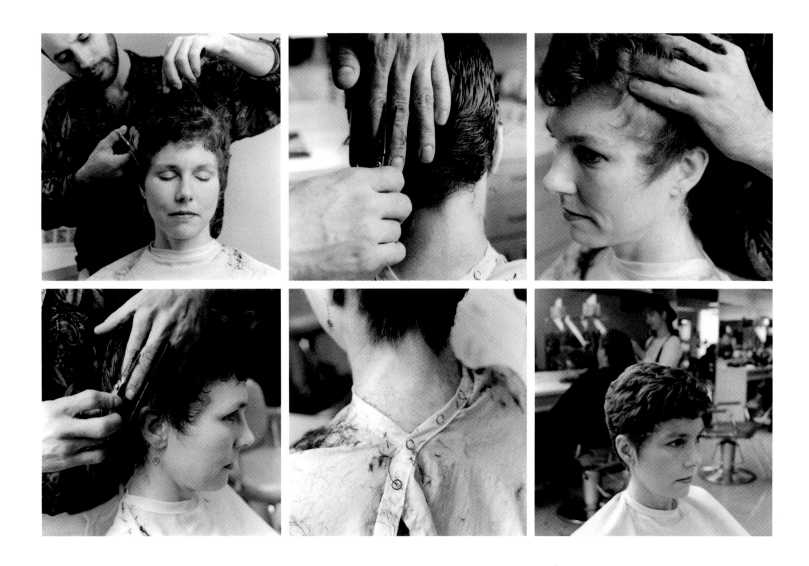

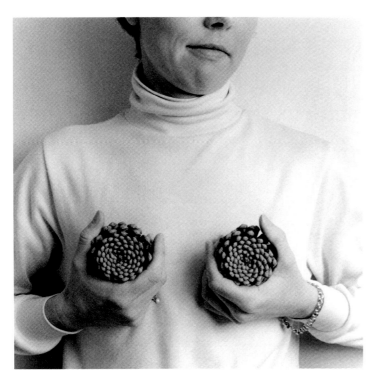 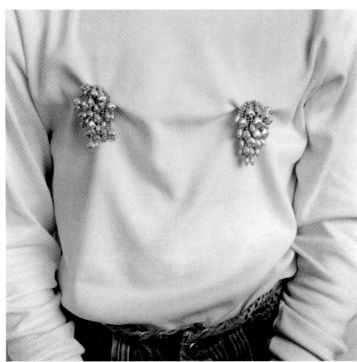

54

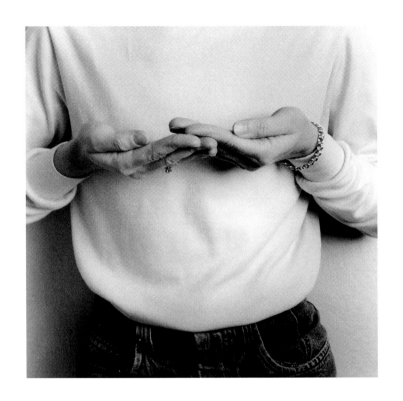

"Clothes don't make a man." And breasts don't make a woman. Breasts come in all shapes and sizes: fat ones, skinny ones, droopy and perky ones. Round, full, flat, uneven. Scarred. Stretched. Tender, comely, curvy. Organic, soft.

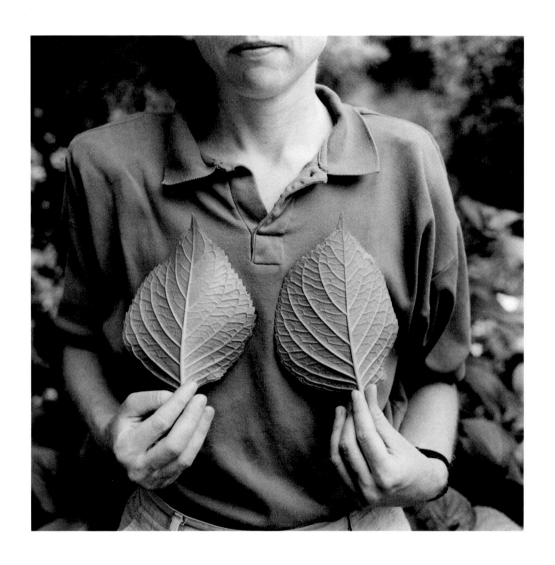

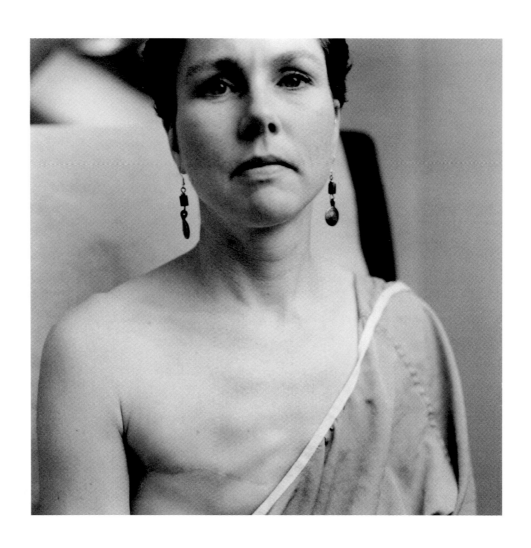

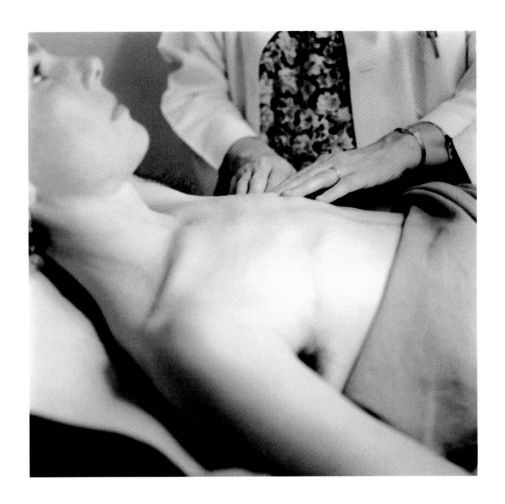

These hands removed the cancer. Whenever I feel something that might be wrong,
I take refuge under the steady, probing competence of these hands. These hands
can feel abnormalities that technology cannot.

I trust these hands with my life.

At first glance, the exam room seems lifeless, sterile.

Then, shadows begin to fill the room with the countless hours of waiting; the boredom and the yawns; the transitions between street clothes and hospital gowns; the physician's patient proddings; the vague recollections of the bad news and the good, the explanations, questions, discussions; the fearful tears and the relieved sighs.

Most vividly, the cast-off gown signals freedom from drugs, needles, blood, cuffs, thermometers, scales, tubes, bags, nausea, dizziness, tears—the physical and psychic punctures. My reality can be my own again.

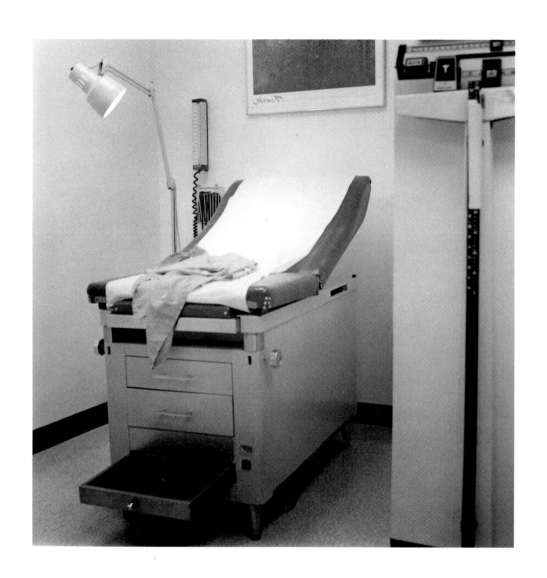

As an adult, I never expected to need my mom as intensely as when I was treated for breast cancer. Throughout, she cared for my most basic needs, giving me comfort for my pain and fear, encouraging me, nurturing me.

Although she lives two thousand miles away, Mom has since transformed into my guardian angel, her voice close to my soul. Her presence is with me every day.

I cannot imagine her pain. A parent is never prepared for her child to die first.

Family and Friends

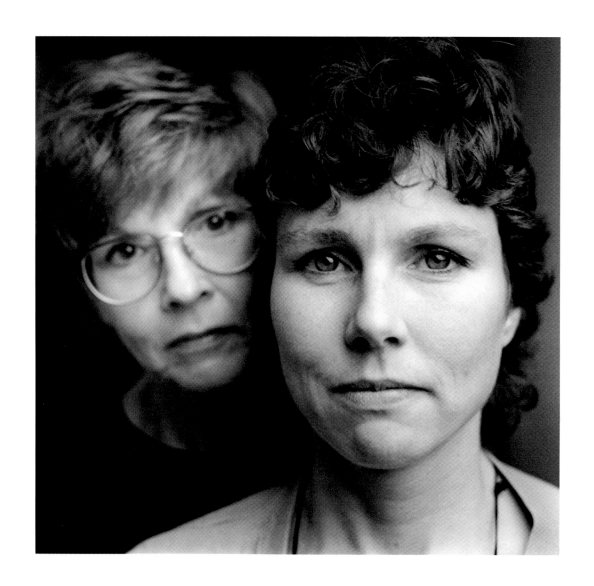

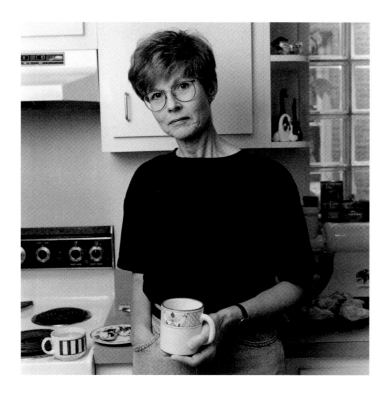

Mom: I think the thing you're teaching me now is to focus on today and not on tomorrow and not on lost opportunities. To take advantage of what is here today.

I feel like I don't have that luxury of time. I'm probably more possessive of my time with you and Staci than if you hadn't had cancer. Which makes Staci call me "interfering" [laughs].

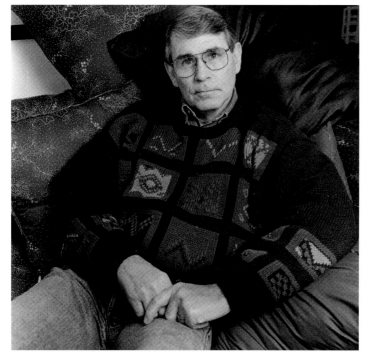

Dad: You have a great education, a super personality, you don't know the limits as far as thought, creativity, being able to contribute something to society, and I think it's grossly unfair that you should die without being able to realize it. I will say what you're doing, your talking to people, your art, I think that contributes. I think that people will benefit from it in a big way. But you're just really a good, loving person and it's really unfair. You shouldn't have to die from cancer.

Staci: I am more aware of my own health and I also try to inform my friends to make them more aware and conscientious of their health care. I have a lot of bragging rights about my sister [laughs] and not so much the illness itself but what you've done with it. So the Races for the Cure and still finishing your Ph.D., getting married, your video and the book you're working on, your continued love of nature.

I just wish that you were physically able to do everything, like go white-water rafting with me, horseback riding, scuba diving [cries], have babies—I wish I could be an auntie, simple things like working out with me. I forget that you're a little bit fragile, because you don't act it. I forget that you have cancer.

In times of crisis, friends surprise you. You think you know people and that you can count on them. But, for whatever reasons, some fade into the background, shying away from illness and hardship. Others unexpectedly come forward, heroically. My friends gave their smiles, hearts, and helping hands.

They:

Cooked dinner

Took the dog for a walk

Scooped the cat litter

Did laundry

Watered the plants

Weeded the garden

Helped with housekeeping

Picked up a few items at the grocery store

Prayed

Sent positive thoughts

Told stories

Made me laugh

Sent postcards from their vacations

Ran a Race for the Cure in
 my honor

Beautified my room with their art

Mailed cards

Sent a pebble from a place special to them

Went to the library

Mailed books

Read books out loud

Picked up videos

Loaned CDs

Made contributions to a breast cancer
 organization (like Race for the Cure)

Organized rides to the doctor

Held head-shaving and birthday parties

Hugged me

Drank twig tea together

Drank carrot juice together

Drank margaritas together

Walked with me

Gently stretched me in yoga class

Told me it was OK to cry

 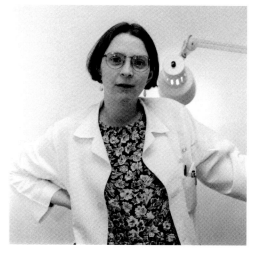

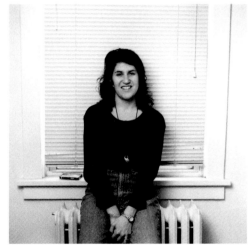

69

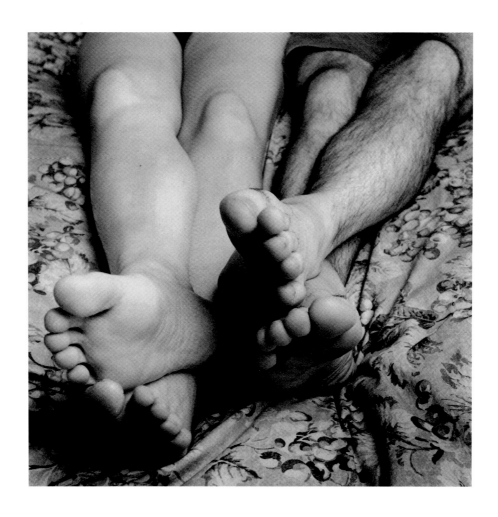

A woman doesn't need a man, but having you around is awfully nice. Ours is a relationship of tenderness, trust, intimacy, and relaxed togetherness, signs of security in our familiarity.

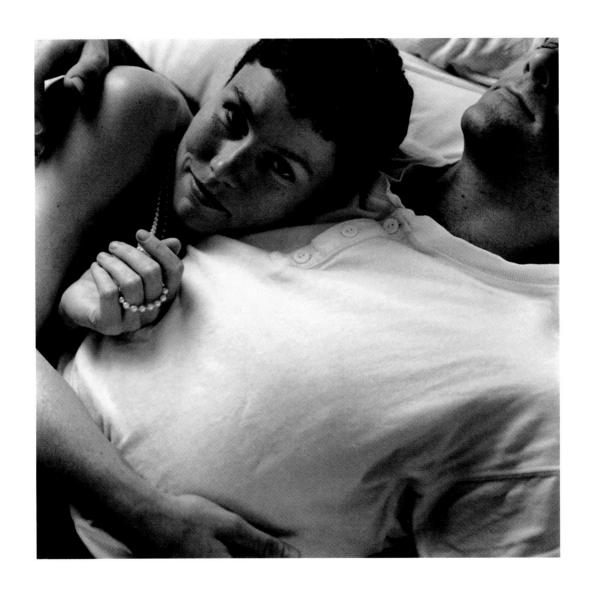

Anniversaries are important to cancer survivors. Often, doctors report the survival statistics in five- and ten-year increments. Patients look to those intervals as milestones. Once reached, they breathe a sigh of relief, as if they've been given the "all's clear" signal. My birthday portraits, each taken on March 14, mark my progress.

On March 14, 1994, I celebrated ten cancer-free months.

On March 14, 1995, I celebrated twenty-two cancer-free months.

On March 14, 1996, I reset the clock. The cancer came back.

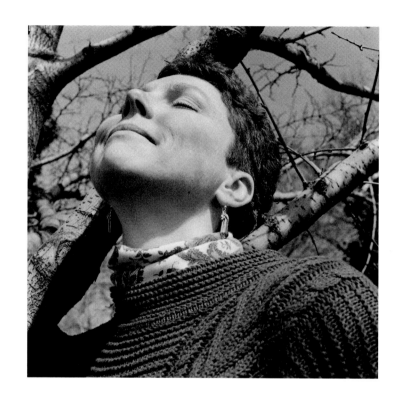

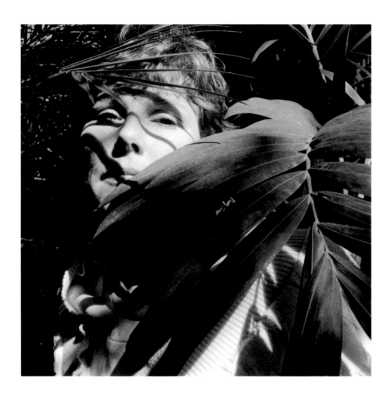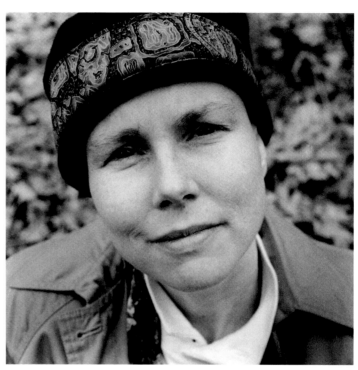

Recurrence

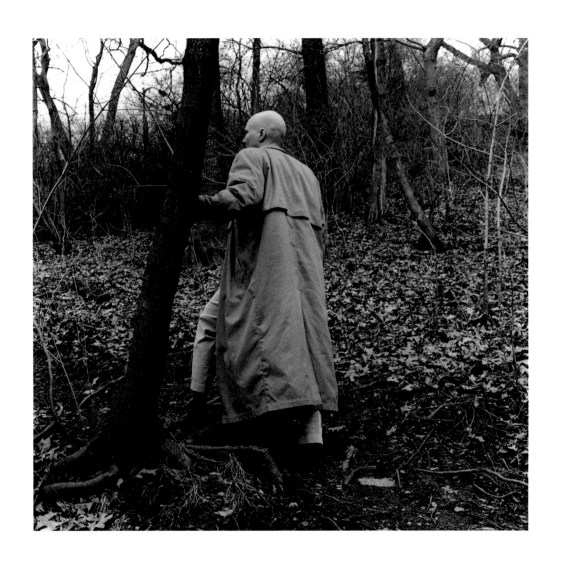

When I was first diagnosed with cancer, I sought aggressive treatment: surgery, high-dose chemotherapy, a blood transfusion, support group—anything to improve my chances of survival.

To hear, two and a half years later, that the cancer has grown anew . . . I'm reeling in disappointment, dread, relief, dismay. My scientific mind knows that my prognosis was not good with the original cancer. Now it is even worse.

This time, I'll go ahead with more chemotherapy. I'll comply with the doctors' intuitions, reluctantly. I don't have the courage or the knowledge to do anything better. Medical science doesn't either. I'm counting on my doctors' educated guesses to arrest the cancer.

After that, all I have is the uncertainty, the waiting, the knowledge that no one can see what's around the corner. With every cough, cold, or sore rib, I will wonder if it is symptomatic of a deeper illness, if the cancer has insidiously returned. It is easy to succumb to the agony of waiting.

77

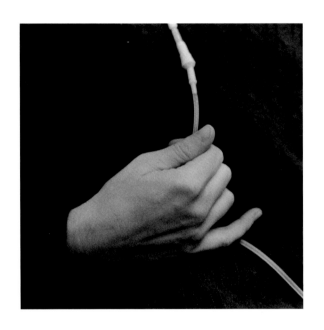

As the chemicals flow, I envision the fluid disseminating throughout my system, starting in a vein, going through my heart to the arteries, then off to the capillaries, a medicine bundle to each individual cell.

As the chemicals flow, I envision a warm, golden light spreading throughout my body, attacking the black dots and spots, washing my illness away. It is a healing fluid, letting me become whole and healthy again.

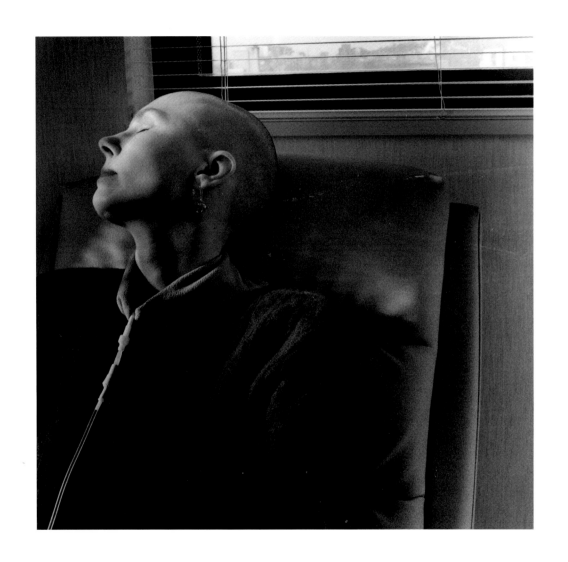

Lately, when I look at my hands, I notice they look more and more wrinkly and dry, reminding me of when I was a girl looking at my great-grandmother's hands. Her hands reflected memories of her life: gardening roses and grooming her immaculate lawn, taking her pole into the wilderness streams for a day's fishing, playing a cutthroat game of hearts, washing her fancy china after a Thanksgiving meal, calculating the finances for her town, giving hugs to her great-grandkids.

My hands also show memories. Although I probably earned each wrinkle, as my great-grandmother did, I attribute each to the drying, life-sucking properties of chemotherapy. It's aging me prematurely.

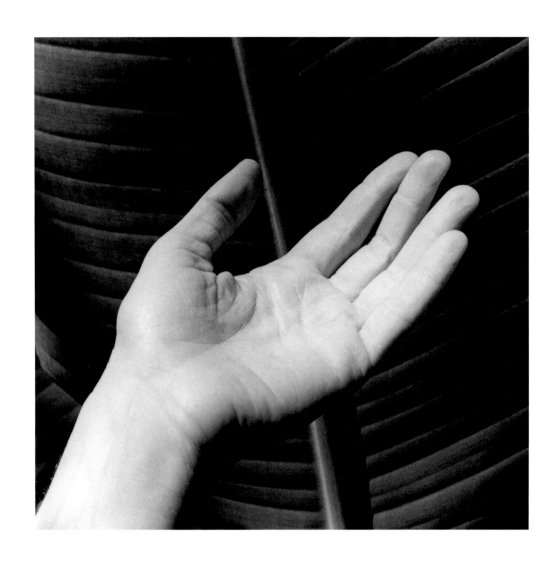

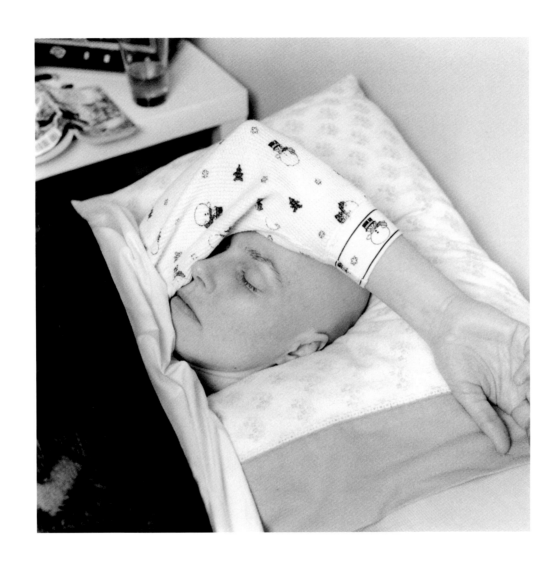

Look Good, Feel Better?

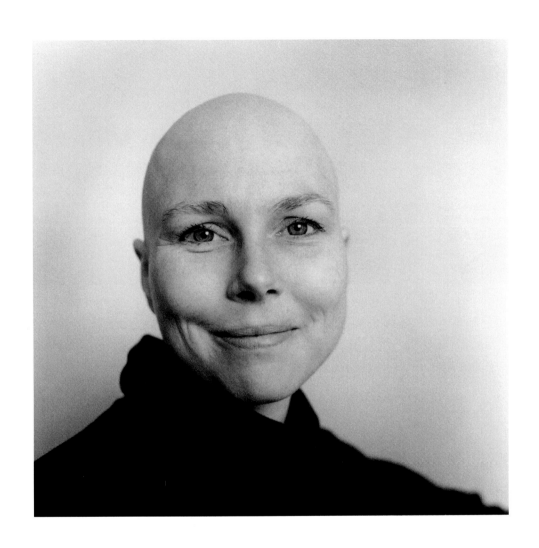

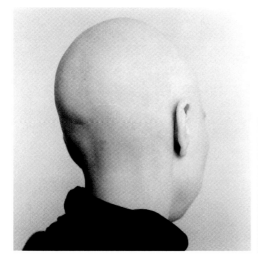 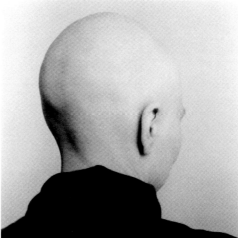 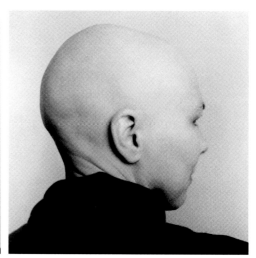

Why is it that I never see anyone without hair¿ Why is it that my doctor insisted I would want to "reconstruct" my breasts¿ Is it so important to hide our appearances, to hide our cancers¿ Why should I feel ashamed¿ Is it so important to conform, to avert the stares and whispers¿

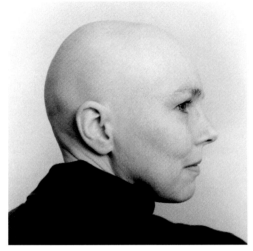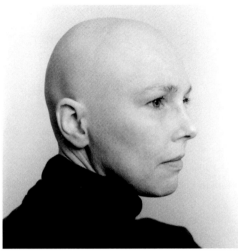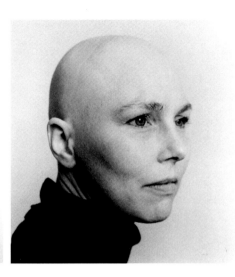

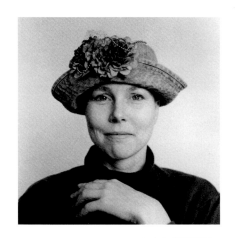

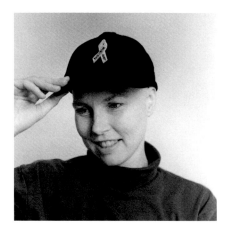

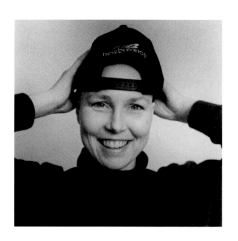

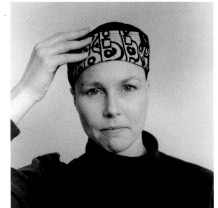

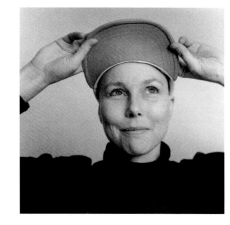

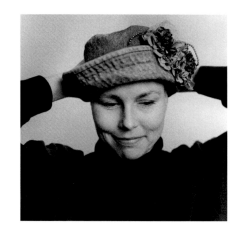

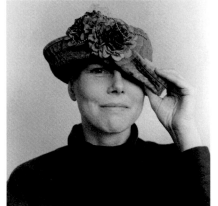

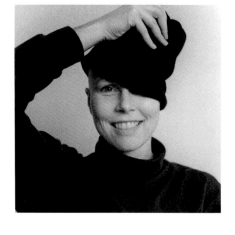

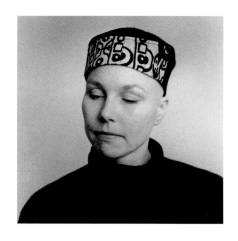

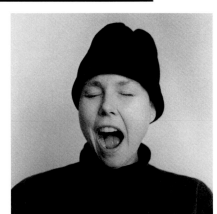

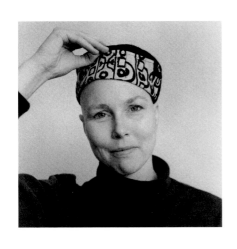

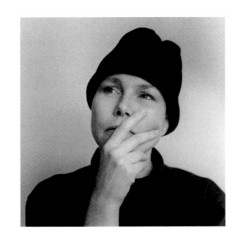

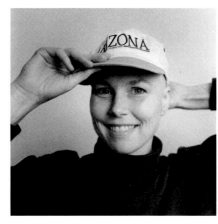

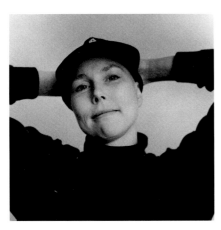

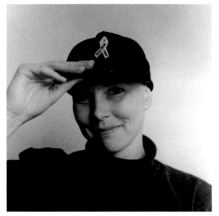

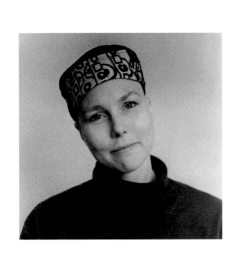

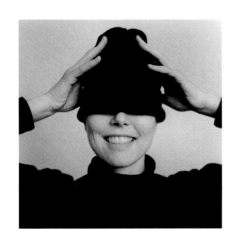

Spirituality

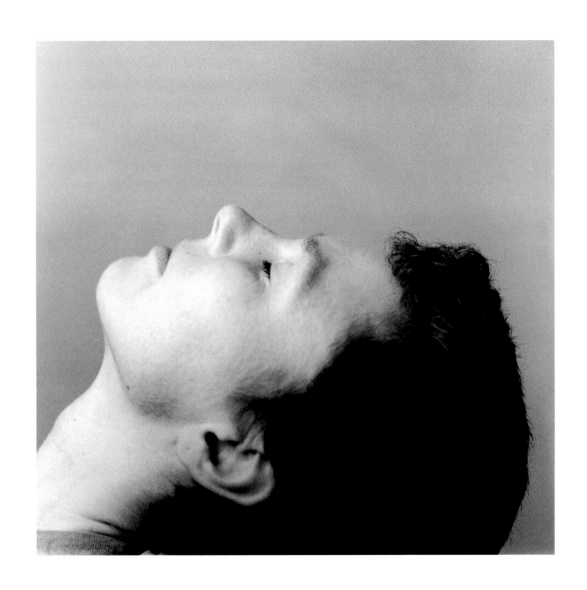

No one knows what's around each corner.

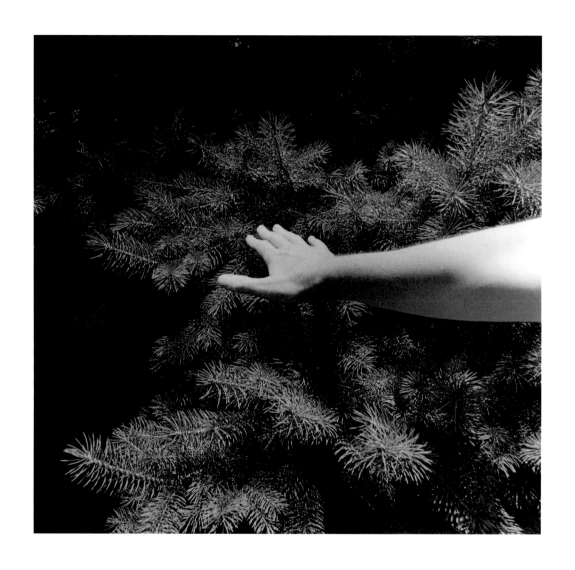

On March 14, 1997, I looked to a new, hopeful future.

On March 14, 1998, I celebrated five years of survival, living and working in Seattle. This year, because I was so far away, Charlee didn't take my picture.

On March 14, 1999, I faced the cancer challenge again.

On March 14, 2000, I turned thirty-seven. I loved and laughed. Cancer didn't matter.

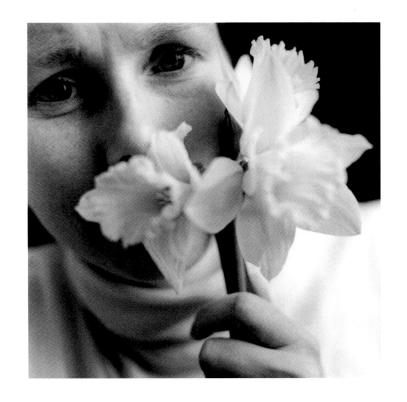

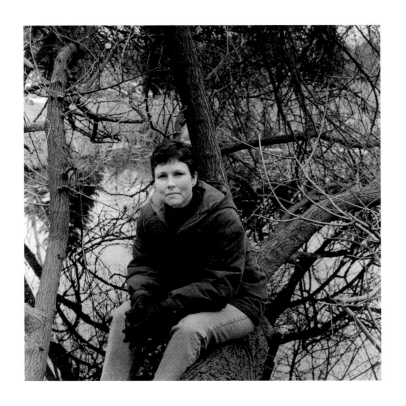

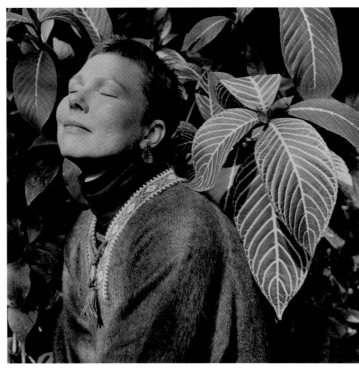

Struggling for a sense of balance, I now live with an emotional intensity, full of spirit and hope. I don't mess around with things that consume my time and energy pointlessly. I keep in mind that loving and laughing are my best healers.

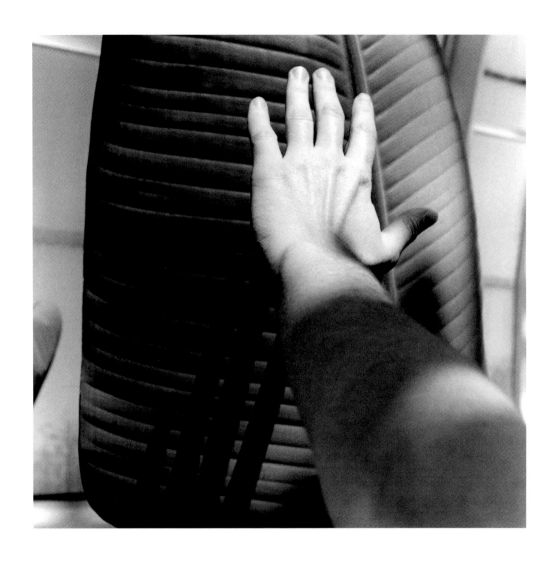

What is in my future: love, laughter, gardens, family, friends, spirituality, travel . . . more of what I love in life. I surround myself with positivity, gentleness, challenge, and hope. I be, I am, until I pass, as we all shall.

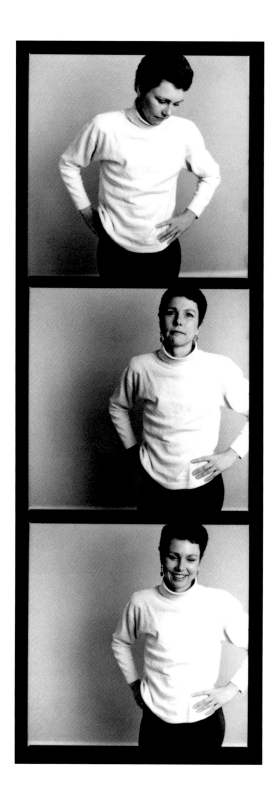

Reconstructing a Life

Jennifer Matesa

Stephanie Byram discovered her cancer the way many people find their cancers: with her own fingertips. She was standing in the shower, washing, and what with the water running and the soapsuds helping her fingers slide over her skin, she felt a hard spot in her right breast. It didn't feel like a pea, like the nurses teach you in breast self-examination sessions. It didn't have smooth edges. It felt as if her breast had thickened, become stiff, on the top outer side. And it hurt.

It was late March of 1993. She had turned thirty on March 14.

It's just my period coming, she thought.

Rare is the woman whose breasts have never been tender in the two weeks before her period. In fact, the most common kind of breast lump is not really a lump at all, but something doctors call "physiologic nodularity," which is like saying, "a normal lump." It's not new, abnormal tissue growing, but a thickening of normal, healthy tissue. Breast tissue is made up of milk glands, milk ducts, and fat. The glands and ducts are very hormone-sensitive, and as estrogen and progesterone drop after ovulation sometimes the glands and ducts thicken and harden; sometimes the nipple feels extra sensitive.

Even when the "lump" is abnormal, it's most often not cancer. When doctors and nurses diagnose a benign lump, they usually tell patients that it's most likely "nothing," which is a doctor's way of saying it's either a cyst (a sac filled with fluid) or a benign fibroadenoma (a tumor, but a harmless one). It is not "nothing," but it is nothing life threatening.

Cysts and fibroadenomas, however, have smooth edges and can be

rolled around like marbles under the skin. Stephanie's lump did not feel this way. And it did not go away after her period came; in fact, it kept growing, and it hurt more. She went to her primary care physician, who sent her for a mammogram and ultrasound.

The mammogram came back showing tiny luminescent specks, like shining galaxies throughout her breasts.

"Her films looked like stars," says Dr. Sally E. Carty, now section chief of endocrine surgery and an associate professor of medicine at the University of Pittsburgh. Carty performed Stephanie's mastectomies and for years served as a sounding board for Stephanie, even after surgery was no longer indicated. The stars, as they appeared on the x-ray negatives, were actually microscopic deposits of calcium that had settled into the milk ducts—the tiny tubes designed to transport milk—in Stephanie's breasts. Even these "microcalcifications" are not always harmful. Tiny calcium deposits are one result of normal wear and tear on the body, and they're common in healthy breasts: most women have some areas of calcification that change very slowly and cause no problem. They have nothing to do with the amount of calcium a woman eats.

If the film shows stars that are larger in size and scattered in no real pattern, then the deposits are probably harmless. If the film shows stars that are smaller and arranged in tight clusters, like galaxies, then it's more likely to be cancer. "There were so many [specks] that the x-rays looked like a little galaxy inside each breast," Stephanie wrote.

The doctors' fingertips also found some evidence that Stephanie's own hands had missed: a swollen lymph node about three-quarters of an inch in diameter in her right armpit, as well as "shotty adenopathy" in the lymph nodes in her left armpit and in her groin. The doctors could feel a "vague thickening" in her right breast and even a little bit in her left. The films suggested there was something dangerous growing in there. "I fear that we are dealing with bilateral breast cancer, and in all likelihood, invasive on the right," wrote Dr. Charles G. Watson, Carty's senior partner.

Watson sent Stephanie to Carty for a needle biopsy of the left breast and a surgical biopsy of the right. The biopsies confirmed the films' grim suggestions. Carty diagnosed "moderately differentiated diffusely infiltrating ductal carcinoma" with "extensive angiolymphatic invasion": the cancer had spread beyond the milk ducts in both breasts and had extensively invaded her lymph system. The size of the tumor Stephanie had felt in her right breast turned out to be more than seven centimeters

—three inches—in diameter: a huge tumor by any standard. In taking the right biopsy, Carty could not obtain a clean margin; sampling with her scalpel, she could find nowhere in the breast where there was not cancer.

❧

All this happened within six weeks. In March 1993, Stephanie was healthy, as far as she knew, and enjoying her boyfriend's company and her graduate degree studies in the Department of Social and Decision Sciences at Carnegie Mellon University. By May, she had been diagnosed with Stage IIIb cancer, the next-to-last stage of the four stages of cancer, and she was facing a double mastectomy with follow-up chemotherapy.

Stephanie's case is an unusual one in a number of respects. First of all, she was extremely young to have contracted such an aggressive breast cancer. Stephanie's breast cancer was the most common type, comprising up to 80 percent of all breast cancer cases; however, "it's very unusual to find widespread infiltrative ductal carcinoma in a woman her age," Carty says. A 2001 survey showed 80 percent of women mistakenly believe breast cancer is the top cancer killer of women. In fact, among women, lung cancer has for fifteen years been the leading cause of cancer deaths, killing seventy thousand women per year, by far more women than all other types of cancer combined—and it is the most preventable. However, because no screening technique is used to detect lung cancer as early as mammography is used detect breast cancer, more women are diagnosed with breast cancer, and many are cured of it. Most of these women are over age sixty. The number of thirty-year-old women diagnosed with breast cancer is very low. According to the National Cancer Institute, among white women ages thirty to thirty-four, each year breast cancer strikes only twenty-five per one hundred thousand— one woman in four thousand, a needle in a haystack. In addition, Stephanie was noted in her chart to have none of the risk factors associated with breast cancer susceptibility. Although there is a history of cancer on her father's side, physicians commonly consider the sentinel risk factor to be breast cancer in a mother or sister. The risk is about six times greater if a mother or sister had breast cancer before menopause. Neither her mother, Barbara, nor her sister, Staci, had had breast cancer.

In her response to her illness, Stephanie informed herself to a higher degree than many patients. "Stephanie was incredibly brave and disciplined in forcing herself to look at bad news and think about the implications," says Carty. She was just eight years older than her patient,

and in her second year in practice when she diagnosed Stephanie. "I was struck by the self-discipline and courage with which she made herself think about what was happening," Carty says. Until the end of her life, Stephanie continued to read exhaustively about her treatment options and, always, about new research into cures. It is evident from her correspondence with friends and other documents she left that she wanted to inform herself of her options to save her body chiefly so that she could protect the life of her mind. She saw her body and mind as connected, and she perceived that connection as inviolate, though vulnerable and in need of a shield from the invasive treatments—as she put it, "the physical and psychic punctures"—she chose to undergo in order to save her life.

More than many patients, Stephanie surrounded herself with family and friends, openly discussed her illness and treatment options with them, and became skilled at asking for help and expecting it of those who cared for her. Carty remembers that at least one family member or friend came with her to every single doctor's appointment, serving as her intellectual and emotional backup when Stephanie became overwhelmed by a deluge of bad news or confused by the treatment options from which she was required to choose. The many people who involved themselves with Stephanie during her illness came to be known as The Entourage. These people came forward, armed and ready to give serious help, much more than sending flowers and cards from time to time. "After cancer," says her mother, Barbara Byram, "she didn't hesitate to express *precisely* what she needed. She wasn't being demanding; she just wanted people to support her." By the time Stephanie's life ended, they had, for *eight years*, cooked meals, delivered meals, walked the dog, scooped the cat box, washed her clothes, watered the plants, weeded the garden, kept house, shopped for groceries, sat with her during chemotherapy infusions, sent dozens of new hats during chemo and radiation, run Races for the Cure in her honor, donated to charities in her honor, bought her a television, borrowed library books for her, bought new books for her, read books to her when she was too ill to read to herself, loaned her audio CDs, held head-shaving and birthday parties, taken walks with her, took her to yoga classes, told her jokes and stories, prayed for her, held her, hugged her, kissed her, and advised her that she could cry and not lose her self-respect. And they did all this gratefully. You can see it in the photographs of their faces.

Many cancer patients are not able to rely on others this much or this

effectively, Carty notes, and it is hardly a surprise that it did Stephanie a world of good. "She wasn't afraid to call in her friends and her family, and they were *so* involved. The degree to which she did it was unusual, and the open-handedness with which she did it was unusual," she says.

Finally, few breast cancer patients document in an artistic manner the process by which they are dealing with their illness. Stephanie's mother, Barbara, and her father, Mike, note that before her diagnosis Stephanie was relatively introverted and private; cancer made her more of an extrovert. Still, despite removing her shirt for the camera and writing text for some of the photographs, there was a private core that remained untouched and unseen by most people, even by many of those in The Entourage, and even by Charlee Brodsky, who photographed her for seven years. "She made it a point to make a lot of friendships," Mike Byram notes. "She could be charming and friendly. It wasn't as natural for her to seek out people to be friends with as it is for other people. It was a learned skill. She taught herself that. And the photographs are a part of that."

Stephanie was interested in sharing with other professionals her coping processes and her artistic documentation of life with cancer. Stephanie never asked Carty to put her in touch with breast cancer patients to share her photodocumentary, but Stephanie did ask Carty to help her arrange a speaking engagement before the physicians affiliated with the Pittsburgh Cancer Institute (PCI). The scientist in Stephanie, perhaps, wished to communicate her experience to other scientists. Carty drafted a letter to the PCI director that says a great deal about the effect this particular patient had already had on Carty. "She is a remarkable woman whose response to her neoplasm has involved much soul-searching and artistic endeavor," Carty wrote. "I personally have learned so much from interacting with her that I think her ideas would be valuable to us."

"You're asking what would I have expected her to say at such a talk? I don't know," says Carty when I ask her about the letter. "The next thing out of Stephanie's mouth was always something new and interesting, and that's why I wanted to hear her talk. You know what I'm saying? I don't know what she would have said at such a talk. I'd be curious to hear it." She leans forward, adding, "Most breast cancer patients don't ask to give talks."

Most breast cancer patients do not pose in the nude for the camera, either—or for anyone else, for that matter. But Stephanie did. She kept

her reasons and purposes mostly to herself, though inklings creep out here and there. "I want to make an emotional statement," she said in a 1994 interview. "I want to engage the viewer in a very personal way, rather than in a confrontative way." The photographs and words contained in this book give a unique and sensitive glimpse into the experience of an individual coping in an active way with life-limiting illness.

"A Most Intelligent Patient": Choosing Treatments

After the biopsies, Stephanie went to Carty's office to discuss the results. Accompanying her were her parents and her boyfriend at the time, Mark Holland. Carty reported the pathology results. Since the tumor in Stephanie's right breast was greater than four centimeters, and since cancer was detected in some of the ten lymph nodes taken from Stephanie's armpits, Carty put Stephanie's cancer at Stage IIIb. She told Stephanie frankly that her odds of long-term survival were less than 50 percent.

"It was the only time I ever saw Stephanie cry," Barbara says. "She cried for a few minutes, then dried her tears, looked at Dr. Carty, and said, 'Well, someone has to survive and it might as well be me. What do we do now?'" After discussing treatment options, Stephanie and her family went out into the waiting room; Carty, Barbara recalls, went back into her office with a nurse and burst into tears herself.

"Until that time with Dr. Carty, Steph didn't think she had cancer that badly," Barbara says. "The doctors were also in a state of shock. Based on her age and lack of family history, it was hard for everybody to accept."

From a medical standpoint, the course of treatment was clear: Stephanie must undergo a bilateral mastectomy. She refused. She believed there must be a way to fight the disease while preserving the integrity of her body.

༜

Stephanie did not leave any recollections about the surgery itself or the way she decided to have it. The only written information referring to it is the medical record, with its spooky, clinical diction: *The right breast shows a diffusely infiltrative ductal carcinoma with an in situ-comedo component and extensive angiolymphatic invasion.*

Stephanie waited a week before consenting to surgery. In that week, she read, and read, and read. And asked questions.

"Stephanie had some denial initially," Carty remembers. It is, after all, a normal response to a prognosis that was, for a thirty-year-old woman, nothing short of disastrous.

"She had the heart, mind, and soul of a scientist. She looked at the whole world as a science experiment," says Barbara Byram. Trained to look at data before jumping ahead with her gut reaction, Stephanie plunged into researching her condition and informed herself thoroughly. She obtained a second opinion and then returned to her first surgeon, Carty, with whom she'd struck up a relationship of trust. She asked to be allowed to review the slides of her biopsies with both Carty and the pathologist. "The pathologist was very patient and explained every detail—even the unclean margins," says Stephanie's mother, Barbara. It took Stephanie a week to reconsider, but the data clearly showed her best chance of survival was to remove both her breasts.

"After much counseling she changed her mind and was willing to proceed," Carty wrote in early May. Her friends and family rallied around her. "She is a most intelligent patient asking appropriate questions and appearing to have a strong support system," Carty wrote.

Stephanie's mastectomies were performed May 24, 1993. "Stephanie's spirits are, after a period of adjustment, remarkably up," Carty wrote on June 4. "She is doing her exercises and eager to start her chemotherapy."

Stephanie talked to at least two oncologists in researching her treatment options. Everyone agreed that she should receive chemotherapy, but the range of treatment—the types of drugs, their dosages, and the length of therapy—was quite controversial. Stephanie decided on a regimen of high-dose Cytoxan and Adriamycin given intravenously in four cycles over four months. Her treatment was overseen by Dr. Samuel A. Jacobs, who remained her oncologist until the end of her life. Jacobs had Carty surgically implant a plastic port under the skin of her chest, where the drugs could drain from an IV bag directly into a large vein, then be immediately distributed by her heart throughout her body, to every cell, in hopes of killing those that multiplied on an abnormally fast timetable.

Unfortunately, as most chemotherapeutic agents do, the Cytoxan and Adriamycin also killed off many healthy cells that multiply quickly—hair cells, resulting in baldness; the cells lining the gastrointestinal tract, resulting in nausea; and white blood cells, resulting in depressed immun-

ity. Stephanie was hospitalized once for neutropenia, fever resulting from a dearth of white blood cells.

Her mother came to stay for a while. She also relied on her boyfriend, Mark Holland, to take care of her. Holland went to all the doctor's appointments with her. He drove the car and paid for parking; he picked up her laundry; he arranged for the housekeeper. "My role was to be there to do all the things that needed to get done," he says. After chemo treatments, he would stay at her apartment and nurse her, giving her injections for six days after treatment to help her blood cells regenerate. Three days after chemo, he says, she would hit bottom and be unable to get out of bed. The injections went into a large muscle, and it took Holland a while to teach himself how to deliver a shot, but he learned.

"By making all those mistakes, I knew what not to do. That was the service I was able to give her," he says. "It was never a question of doing it or not. People want to be a part of something that's bigger than going to work, going to school."

He also provided emotional support, holding Stephanie when she was sad. Emotionally, being a "chemo-chick," as she called it, was very difficult. In addition to all the other side effects, there was the disabling fatigue, which was anathema to Stephanie's view of herself as a competitive, energetic woman who ran at least four miles a day and did not need naps. It was the beginning of learning to slow down. When she was in bed, she had to appreciate what she could see from over the hem of the covers: her dog, the flower in the vase on the windowsill, the friend who was with her at the time. She learned to focus not on what she had lost, but on what she still had.

༄

Cytoxan also put her ovaries out of action, which meant her periods stopped and she experienced hot flashes: instant menopause. Or, as doctors say, premature menopause. Cancer had taken her ability to bear and nurture a baby. It had irrevocably changed her accustomed ways of being sexual. "It was a loss for me not to have breasts. I desperately grieved and missed not being able to nurse a child," Stephanie said in a background interview videotaped by WTAE, the ABC affiliate in Pittsburgh, for an eight-minute spot that aired in April 2000. "And I miss the implications for sexuality: I have had to change—we have—my partners and I—have had to change the way we've had sex."

Stephanie wanted children. She wanted to be a mother. Imagine the

choice: if she wants to live, she has to ingest a chemical that will render her sterile; if she chooses motherhood, she dies. She chooses the "medicine." After her first few doses, her period comes, as usual; peters out; then it doesn't come again. She has night sweats and hot flashes, like a woman twenty years older than she. Her period came and went over the years, depending upon the treatment she was engaged in; however, had she become pregnant, the skyrocketing estrogen levels would have posed a huge risk for a recurrence. So pregnancy was out.

Part of living with cancer meant finding and claiming the generative parts of herself and her life. This entailed endowing her experiences with meanings that ran counter to the cultural perception of them: chemo not as destructive and to be feared, but as life-giving and to be embraced. The photographs of her receiving chemotherapy are of a woman who has chosen to turn her face not into shadow but into the sunlight streaming through the window.

༄

She grieved her losses. She did not dwell on them. She was determined that she would beat the cancer. With that always in mind, she learned quickly that to dwell on the losses—on what the disease had taken—would be to let the cancer win. She learned quickly that every thought is invested with energy, that her energy was a resource that must be conserved and carefully built back, and—possibly what constituted the core of Stephanie's indefatigable optimism—that she had control over every thought that was admitted into her mind. Therefore, she'd better choose well which thoughts to allow access. If she admitted self-defeating thoughts into her consciousness, she would indeed defeat herself. So she nurtured thoughts of recovery and health. Never mind that the drugs coursing through her blood—absorbed by capillary action through the membranes of each and every cell in her body—were so caustic to life that they had stripped her of her hair, her guts, her procreative potential. These were facts, but to her, a fact that possessed equal if not greater power was that the treatment, caustic as it was, could possibly save her life. Therefore, she accepted it, and endowed the drugs with her own meanings.

"As the chemicals flow, I envision the fluid disseminating throughout my system, starting in a vein, going through my heart to the arteries, then off to the capillaries, a medicine bundle to each individual cell," she wrote. "As the chemicals flow, I envision a warm, golden light spreading

throughout my body, attacking the black dots and spots, washing my illness away. It is a healing fluid, letting me become whole and healthy again."

"With alacrity she adapted to it, and went on, and tried to live a different life," Carty says. "Rather than resisting or swallowing, she said, 'OK, these are the facts; let's party.'"

"Maybe her attitude helped her survive?" I ask.

"Yes," says Carty. "There's no data, but her attitude probably helped her live so long."

⌇

Over the next seven years, the cancer recurred: in 1995 in the lymph nodes of her left armpit; in 1997 in the lymph node above her left collarbone; then, in 1999, in her spine and pelvis, and the next year in her liver and brain. "Poor Steph didn't get any breaks when it came to cancer," says her mother, Barbara. "All the worst things always happened, but she continued to think the best would happen." Stephanie became a "chemo-chick" time and time again in her effort to beat cancer. She took drugs with all sorts of strange, exotic names, from Aredia to Zalendronate; she took Tamoxifen and Taxol, a drug derived from the yew trees in her native Pacific Northwest. She took Procrit to promote blood-cell regeneration, and she took Decadron to decrease swelling inside her skull. She lost her hair four times; she regained and lost and regained her period again; then, when it was determined that a recurring tumor was estrogen-sensitive—and since estrogen promotes cellular growth—she chose to have her ovaries' hormonal actions pharmacologically blocked, rendering her sterile.

Chemo wasn't the only treatment she received; she also received radiation when the cancer metastasized—or spread—to her pelvis, her lumbar spine, her liver, and her brain. "RT," as doctors call radiotherapy, was used for the bone and brain tumors. Since radiation is the same as having repeated shots of the sun close-up, this treatment has its own side effects: sunburn on the skin and in the viscera, with associated vomiting (if the tumor is near the stomach), sore throat (if the tumor is near the larynx or esophagus), diarrhea (if the tumor is near the intestines), or baldness (if the tumor is in the head, as was Stephanie's case).

To deal with the many side effects of her treatments, and to boost her morale, she explored various "alternative" therapies. "She took a lot of

vitamins," says Barbara. "When she was having radiation in Seattle, she visited a traditional Chinese medicine person who gave her herbs that she had to boil up and drink. He also recommended a diet, but it was so restrictive that she felt she couldn't do it." The diet included white fish, rice, certain vegetables, and some limited fruits. Though cancer spurred her to drink no caffeine and almost no alcohol, to eat no meat other than fish and chicken, to give up most sweets, and to buy organic, in the end she quite seriously decided that her favorite chocolate-chunk ice cream increased her quality of life too much to do without it. "My most important lesson is forgiveness," she wrote in 2000. "Despite my best intentions, I don't always do the best things for myself. Those sour cream and onion potato chips are just too tempting!"

She went to an acupuncturist. She had a massage therapist. She splurged on spa days that often included her mother. Of course, insurance did not cover these services. Asked in the 2000 interview what advice she would give to cancer patients, she talked about what these "experiments" meant to her. "I would recommend the willingness to take risks, and to experiment. Because," she said, smiling, "how will you know what's best? Unless you try? So try that wacky diet if it appeals to you. Try a new prayer. Try a new therapy with a doctor, if the doctor believes it's something that could be very good for you. And then, last, reflect on that. Reflect on what those experiences have brought you, and grow from the ones that seem to work for you. And be patient. It takes time."

Her willingness to experiment led her to negotiate with practitioners of a variety so wide they might boggle the mind of many patients. At any given time, she might be talking with a primary care physician, surgeon, oncologist, radiologist, acupuncturist, nutritionist, Chinese herbalist, massage therapist—and attempting to integrate the parts of these modalities she felt benefited her into a unified wellness regimen. "I have learned to take things into my own hands," she said in 2000. "The challenge for the cancer patient is learning how to integrate all this stuff into a treatment that is the right treatment for me as an individual. And that is not easy. It means learning how to speak with the surgeon, how to speak with the oncologist. Not only to understand what words are comfortable for them, but trying to communicate how you want to make decisions together. It's up to me as a patient to communicate my values, so they can help me understand what the right options are, and what the right trade-offs are."

"She was going through the process of having and then dying from breast cancer, but she was also willing and insightful enough to talk about the process. It's really interesting, and really important feedback for a doctor," says Carty. "The way that she was courageous about her pain allowed the doctor to courageously listen to her. She was being brave in talking about it, so I could be brave in talking about it too."

Stephanie's proactive communication with her physicians and her desire to take charge of her treatment distinguished her from other patients, most of whom would rather place full responsibility for their treatment and cure into their physicians' hands. Eventually she and this ad hoc medical advisory board she'd put together arrived at a kind of mission statement for treatment of her cancer. "I am willing to undergo any therapy that will help me live a longer quality life," she said in the 2000 interview. She emphasized those words: *A longer. Quality. Life.* This mission statement guided Stephanie for years through a daunting array of treatments and lifestyle choices.

ɜ

Whatever course of treatment she was currently engaged in, it is apparent from Stephanie's writings and interviews that she engaged in just about no self-pity, and that she always decided for herself what the treatment would be, and what it was going to mean to her. The first time she went bald, for example, she took the bull by the horns. The night before her first chemo infusion, Stephanie had a big party and her friends helped her shave her head. "I mean, that's an unusual degree of reliance on and confidence in one's friends, and it's an amazing degree of support by the friends for the person," Carty says. "I told patients about this for years— that there are ways to deal with the loss of hair through chemo that aren't sad, and that I'd had a patient who held a head-shaving party." On later occasions, when chemo or radiation took her hair away, Stephanie played it light. Having begun a series of twenty sessions of whole-head radiation, here she writes just six months before she died to the "StephTrackers," the e-mail newsletter she and her husband, Garth Gibson, periodically sent to members of The Entourage:

Date: Tue, 7 Nov 2000 01:55:40 -0500
Subject: Bald is Beautiful
. . . As the doctors predicted, I lost my hair due to the low-dose radiation
treatments. But I had the impression it would be a more hair-thinning experience,

slow and gradual. Au contraire!! We're talking catastrophic failure. It came out all at once on Sunday, Oct. 29, and is now happily degrading (I think) in my backyard compost pile.

The moment my hair started to leave, I admit, was not a happy one. There were tears, many episodes of them. Although I've been undergoing treatment for metastatic disease for the last eighteen months or so, it's been a long time since I've LOOKED like a chemo-chick. It made me sad to think of the attention I would draw. Up to now, I've been able to discuss my illness on my terms (or not). Now, I'd be open to the stares of strangers and the sympathy of friends (who, because I usually look pretty good, might not remember that I'm undergoing active treatment. We could relate on more "normal" terms, if I chose).

Anyway, all of the unhappy, out-of-control, loss, grief, chemo-chick reaction was short-lived, a few days. It turns out that I really like being bald. Many of you know that I love short hair. Being bald is not much different except there are No Bad Hair Days. Fortunately, I have a face and head shape that goes with bald (excepting the cheek puffiness from steroids, but we are already tapering my dosage to get off them altogether soon). Hats are a popular fashion so few people seem to notice that there's no hair. And I look good in hats. And I still have eyebrows.

Though she had lost her hair three times before, she was far from being desensitized to the continuing losses that treatments wreaked upon her body and life. Still, in coping with hair loss, Stephanie never opted for wigs: she didn't hold with faking any part of the body, even the hair. Instead, she often went bald or, especially when it was cold, she wore hats. She routinely listed "sending a hat" (along with "cooking a meal—with vegetables" and "sending positivity") as a way members of The Entourage could help her if they were looking for ways to contribute. The above post concludes by describing new hats that friends have sent and thanking them for their thoughtfulness, as well as a hinted invitation to those who haven't sent a hat to feel free to do so. "My sense of style, my emotional health, and my body temperature are all very grateful to you," she wrote. "Many thanks for your thoughtfulness and quick reactions—it's more than I could have managed on my own."

Because she spent much of her last eight years in treatment, she spent much of that time engaged in battle and mop-up operations. "When I was first diagnosed with cancer," she wrote, "I sought . . . anything to improve

my chances of survival." Until the last six months or so of her life, in 2001, the fight was always a fight to win.

Reconstructing Her Life

Choosing not to reconstruct her breasts was perhaps the pivotal decision Stephanie made during her experience with cancer.

It is clear from her writings that Stephanie perceived a great deal of pressure from the medical community and the culture at large to rebuild the body parts that had been taken by cancer. She saw this pressure as unreasonable and, eventually, as absolutely contrary to her emotional recovery. "Breast reconstruction never seemed like the right choice to me," she wrote. "The more I learned about it, the more it turned me off."

Stephanie met with a plastic surgeon before her surgery and afterward, to learn about her options. There are two basic ways of replacing breast tissue, skin, and nipple where a breast has been removed: the "flap" method, in which a flap of muscle is tunneled from another part of the body (usually the abdomen or back) under the skin and over to the breast area, thus molding a new "breast" out of existing tissue; and the implant method, in which a sac filled with saline, silicone, or a combination of both is attached to the chest. In both methods, the reconstructed breast is encased in skin grafted from the abdomen, thigh, or buttocks. After scars have healed, a spot is tattooed to resemble a nipple. Both methods add operating-room time to the mastectomy. The flap methods add three to six hours of surgery more than the implant methods, they inflict more pain because of the muscle tunneling, and they require a longer recovery, but many women feel they result in a more "natural" looking breast—one that is warmer, softer, and gains and loses weight with the woman's body. However, the flap method, because it "borrows" muscle from abdomen or back, can result in muscle weakness or even disability in that area, though it is said that many women are happy to receive the "tummy-tuck" that automatically results from abdominal flap reconstruction.

Planning for reconstruction early in a patient's diagnosis is considered state-of-the-art, classy "breast-centered" care; indeed, American insurance companies have been required by federal law since 1999 to pay for breast reconstruction if they pay for mastectomy, thus removing the financial disincentive from planning for this operation as early as possible. "A real breast center tries to [offer reconstruction] up front," Carty says. "I set her

up to meet with a plastic surgeon ahead of time. My words are always, 'Why don't you go meet with the plastic surgeon and see what they have to offer?'

"I also always say, 'Or you may not want to,'" she adds. "Or she might want to do it later. I personally favor delayed reconstruction, which happens six months later. That's an option that's used for bad-prognosis cancers, like Stephanie's, because the likelihood of recurrence is greatest in the first six months, and you can feel that as a nodule in the chest wall, which your reconstructed breast tissue would hide."

It is often noted that the greatest advantage of immediate reconstruction is that the patient will never experience her body as breast-less— she will wake up from the anesthesia with both breasts. Studies have shown that women who undergo breast reconstruction at the same time as their surgery experience speedier recoveries and less depression than women who do not choose reconstruction, because they feel more of a sense of control over their treatment and appearance. Breast reconstruction is described by women's health centers of excellence—for example, the Johns Hopkins Breast Center—as being the best way for a breast cancer patient to restore her self-esteem "in order to re-enter society with strength, confidence, and vigor."

I can hear Stephanie scoffing: "As though, just because she had cancer, just because she lost her breasts, she had *left society!*"

Statistics vary from center to center, but in general, 50 to 60 percent of American women choose breast reconstruction following mastectomy. That means nearly half of all mastectomy patients, or about 35,000 women per year, choose not to have reconstruction. "These include golfers, women who have always suffered from back pain from big, heavy breasts, and people who are just comfortable without it," says Carty. Also, some women, like Stephanie, don't wish to put their bodies through additional surgery. However, Stephanie did more than just decline breast reconstruction. She took a stand against the medical establishment's focus on what she considered an unnecessary, painful surgery that promoted an unrealistic vision of womanhood—under the guise of helping women "recover" from breast cancer and "re-enter" the world. "I couldn't imagine asking my body to undergo additional, invasive surgeries merely for the sake of appearances," she wrote. For her, reconstruction became a flashpoint in her recovery from breast cancer.

As always, her friends helped her think this decision through. One discussion in particular clinched her choice. Stephanie had a conversation

with a male friend around the time she was mulling over the idea of reconstruction. One day, on a walk, she asked him whether he would find a woman attractive if she did not have breasts. "I will never forget his answer," she wrote. "He said that he's dated quite a bit and seen a lot of breasts. In his opinion, breasts were overrated. In fact, he took the radical view that it would be erotic to date a woman without breasts."

After her surgery, she sorted through her grief, wondering about its sources. "Lost / Womanhood / Sexuality / Motherhood / Why am I so sad?" she wrote. "What did I need to recover those feelings? It turned out not to be breasts. I wanted to reconstruct my life, not my body."

❧

"If women want to have reconstruction, if they want to have implants, if they want to wear prostheses, great. But I think they should be given some information about not having reconstruction, as well," she said in the videotaped 2000 interview. As a scientist, Stephanie studied the decision-making process. After diagnosis, she focused her research specifically on the information health care professionals give women about their breast cancer diagnoses and treatment options, and how this information impacts their choices. From an academic standpoint, she was committed to seeing women get more information about all the options, including not having reconstruction. But her personal feelings about this merged with her professional commitment.

Historically, reconstruction became an option only very recently—in the last ten years. Before that, women had no option at all for reconstructing their breasts. The only "information" they were given was that their breasts would be removed. In reading Stephanie's viewpoints about reconstruction, I wondered whether the medical community could reasonably be criticized for letting the pendulum swing for a while in the opposite direction.

In personal interviews, Stephanie's thinking with regard to reconstruction is fairly inclusive, and less critical of women and physicians. In her writings, however, her thinking becomes a bit more uncompromising. "Reconstruction has a more insidious side," she wrote in 2000. "Some doctors offer to remove a breast, then reconstruct another one in the course of the same surgery. Women wake up as if nothing happened, the scars and pain resembling the inconveniences of an appendectomy, not cancer." There is no way a woman undergoing same-day reconstruction could possibly wake up "as if nothing happened." The stand she takes

betrays her partisanship in this matter: she has committed herself to psychic restoration *in place of* physical reconstruction. There are many women, of course, who choose both, but Stephanie chose one in lieu of the other. For this particular breast cancer patient, the choice was absolute: *If I reconstruct my body, I will not be able to reconstruct my life.*

Reconstruction "allows insurance companies to provide less expensive 'one-stop shopping,' physicians to make up for delivering the terrifying diagnosis by 'fixing it and making it better,' and patients to deny the life-threatening possibilities of their illness," she wrote in 2000. "Would the patient never be at risk for a recurrence, denial might be an appropriate response. However, some 5 to 50 percent of patients will confront breast cancer again . . . And, if one believes in the mind-body connection, then the sooner we begin to address it, the healthier we'll be." These adamant arguments don't acknowledge that, at a number of points in her experience with cancer, Stephanie herself denied the life-threatening possibilities of her own illness. Her family and friends point out that Stephanie didn't consider herself to be sick, and that she did not believe cancer would take her life until the very end—in the last couple of weeks. Denial of the threat to one's life is indeed an "appropriate," natural, most human psychological response to cancer. In addition, many women simply do not "believe in" or comprehend the idea of "the mind-body connection," and they still survive longer than expected.

Under the striking series of headshots of herself without hair, she writes, "Why is it that I never see anyone without hair? Why is it that my doctor insisted that I would want to 'reconstruct' my breasts? Is it so important to hide our appearances, to hide our cancers? Why do I feel ashamed? Is it so important to conform, to avert the stares and whispers?"

ॐ

There are some facts of her life that are invisible here. For example, when she wanted to take control of her treatment-induced baldness, or when her hair grew back in, Stephanie patronized one of the city's poshest salons as a client of the owner, who charges upwards of sixty dollars for a cut, employs a master wig-maker (should a client choose to have a wig made), and operates a salon on the premises of the University of Pittsburgh Cancer Institute. The facts of her life beg the question of how she might have felt if she'd been born into a poorer situation—or into an earlier, pre-Twiggy, pre-Sinead O'Connor era in which flat-chestedness

and baldness were social anathema and reconstruction was medically impossible. Had Stephanie chosen to reconstruct her breasts, she had a sensitive female doctor at the ready to refer her to a plastic surgeon whose expertise was breast reconstruction, and she had insurance that would pay for the whole thing. Not every breast cancer patient has these resources. One thing that enabled Stephanie to reject reconstruction so firmly was the fact that she enjoyed the security of being able to afford the most progressive, expensive remedies to the problems facing her.

In perceiving her doctors' offers of reconstruction as "insistence"; in asserting that she "never" sees "anyone"—any woman, that is—with a bald head; in implying that the culture forced her to hide and to feel ashamed, Stephanie sounds as though she felt quite alone in her decision to reject reconstruction. More than thirty thousand other American women opted for no reconstruction in the year Stephanie made this decision, but she sounds as though she had no company. Of those thirty thousand women, however, it is likely that only a very few made the decision the same way Stephanie did—making mental and emotional reconstruction contingent upon the adamant refusal of physical reconstruction. Instead of declining for personal reasons, Stephanie refused for cultural reasons. Standing in the middle of her own tragedy, her questions went past the personal—*Do I want breasts? Am I "comfortable" without them?*—into the cultural, to articulate the underlying questions behind breasts as icons, behind the focus of women, men, and the medical community on reconstruction: *Why are we so obsessed with having breasts in the first place? Why should having fake breasts console any breast cancer patient, when the questions of vitality and mortality raised by cancer are so much bigger and more meaningful?*

Perhaps there was a payoff for her in feeling so solitary, in making this singular protest. For Stephanie, it was important *not* to conform in certain ways. This was how she asserted her continuing existence. She would *not* get a wig; she would *not* reconstruct her breasts; she would *not* wear prostheses, or think about her prognosis. She needed to be different, if she was going to survive. Her writings declare, tacitly, bravely, "OK: This rare cancer picked me. I'm going to be one of those rare women who survives this rare illness." In other words, "If I do what everyone else does, I'll become a statistic, like the rest of them." Stephanie wanted to live outside the range of statistics and prognoses: these were more weapons in cancer's vast arsenal that could puncture the integrity of her body-spirit. She needed to be in that group of less-than-50-percent of

women who survive Stage IIIb infiltrative ductal carcinoma. In her mind, rejecting the option of reconstructing her breasts radically differentiated her from the majority of women like her, who would not beat it.

That's not what made her different, though. What made her different was that she had the courage and the generosity to share her body's changed appearance with other people. Many women choose to reconstruct their lives; not many women are so open about how they do it. Stephanie writhed inwardly when strangers stared at her flat chest and bald head, but she also believed that their responses emerged from human nature, and that to skirt these responses by changing her appearance—"hiding" behind the pretense of a wig, a fake breast—would be not only to puncture her own integrity but also to violate the integrity of the starer, to deprive that person of the dignity that comes with the ability to feel the spectrum of natural responses: fear, curiosity, disgust, wonder. Stephanie was confrontational, however much she didn't want to believe she was, and she confronted people on her own terms. She wouldn't have lifted her shirt on the bus, or perhaps not even for most colleagues or friends; but here she is, for you, a total stranger, with no wig, no hat, and no clothes.

The Photodocumentary

The significance for Stephanie of her decision not to reconstruct her breasts is most evident, of course, in the photographs Charlee Brodsky made of her body. The photographs have been exhibited in various galleries, featured in an Emmy Award-winning documentary video, presented on a Web site, and published in the local newspaper, several magazines, and a literary quarterly. Venus alone has shown many people—starting with Stephanie herself—that breast cancer survivors can be seen as beautiful rather than as mutilated.

Early in 1994, about eight months after her surgeries, Stephanie decided to enter the Susan G. Komen Race for the Cure. At the time Stephanie entered her first Race for the Cure, there were fifty-seven of these five-kilometer runs; now they are held in 116 U.S. cities and five cities throughout the world to raise money and awareness for breast cancer. She decided to use her experience with cancer to garner publicity. In need of a press photo, she approached Brodsky, who she knew from Carnegie Mellon University circles. Brodsky's husband was at that time the head of the Department of Social and Decision Sciences, where

Stephanie earned her master's degree and later decided to go all the way—for a Ph.D.

From the first, Stephanie was very forthcoming with the physical evidence of her cancer. "I saw her the day before her surgery," Brodsky says. She said, 'Do you want to feel the cancer?' She took my hand and guided it to the lymph nodes under her arm. It felt just like they always say cancer feels—like a little pea. A little, hard pea."

After surgery, "showing her body was one way of accepting her body," Brodsky says. "She actually showed one other person on the CMU faculty, a man who was close to her research. She lifted up her shirt so he could see."

Stephanie did the same thing for Brodsky on their very first shoot. They met to make images of Stephanie in her running gear for her Race for the Cure PR packet, but they wound up putting those pictures off. During the first meeting, there was some small talk and catching up, with Brodsky making some initial photographs of Stephanie's face. Then suddenly Stephanie said, "Do you want to see the scars?"

"Her eyes turned quite serious—the eyes were no longer talking. It was almost as though I wasn't there anymore," Brodsky notes. "These were probably the most direct photographs we've done in all our sessions."

Stephanie lifted her shirt, and Brodsky shot the first series of photographs of Stephanie's torso—clinical, cold, confrontational images. When printing, Brodsky says, she chose to crop Stephanie's eyes out of the frame "almost to depersonalize it more. Like she's not an individual."

Brodsky keeps contact sheets of all her photography sessions, and in contacts of this session, you can see Stephanie's face. In the smiling headshots, her face is at ease: *I've recovered from this thing; I'm ready for anything*. She lifts her shirt; the smile fades, and a grim line appears between her eyebrows: *This is me. You want to see me? Then you have to look at this as well.*

"I rather dislike these direct photos because to me they're very in-your-face—shocking, direct, frightening, without context," Stephanie said in 1994 of these images.

But in those images of her body, Stephanie and Brodsky found enough of interest to each of them that they decided to meet again. It became a seven-year working relationship that also developed into a deeper friendship. "It was a very different kind of project for me—to

photograph one person for so long," Brodsky says. They had no definite timetable but met every so often, with Brodsky taking the lead on scheduling and making work prints.

The second session took place on Stephanie's thirty-first birthday, about ten months after her diagnosis. They worked off and on throughout 1994 and 1995, after Stephanie's cancer recurred for the first time, in her left armpit. Even after 1996, when they stopped meeting regularly, they always met on March 14 to shoot a birthday portrait at Phipps, the botanical gardens and conservatory near the universities. The birthday portraits, as Stephanie writes, marked off the years of recovery from cancer and recurrence.

"I think the project was important to her right off the bat, but it became more important to her after the first recurrence," Brodsky says. One of Brodsky's favorite images, from an artistic standpoint, is one of the photos taken on Stephanie's birthday in 1995: Stephanie, bald and wearing a trenchcoat, is walking behind the conservatory. The trees are leafless, their roots partially bare at Stephanie's feet. The carpet of dead leaves lends the image a rough, dry, despairing mood. The perspective is three-quarters rear—you can see only a sliver of Stephanie's chin and cheek; from this angle the composition is eerie, like a tarot card.

"She knew the recurrence was very bad," Brodsky says. I mention that the atmosphere of the photograph is haunted, and Brodsky agrees: "To me, it's like a World War II image. Very grim and ominous, with a desolate landscape." Yet the reality in the photograph is that Stephanie is treading a path. Her head is up; she is stepping over the obstacles in her way; she is wearing protective clothing; she is holding onto a tree for support; she is going somewhere. She is moving into the unfamiliar.

Another of Brodsky's favorite images shows Stephanie holding hydrangea leaves in front of her chest. In this image, the set of her lips suggests that she is asking for your attention; the leaves locate the spot her breasts should be, something her viewers expect to see but will not find. She seems to be saying, *Here's what I am missing. What have you lost? What has been given to you and taken away again? What have you asked for and been denied?* The leaves' veins stand in relief like engorged blood vessels. The leaves point up.

This is the intimacy of these images. The Venus series asks for the same level of intimate sharing from the viewer: *Here's the beauty I didn't expect to find in myself. Where is yours?* While they were shooting this

picture, Brodsky worried that this image would "read" too much like a fashion photograph. The work print that Brodsky gave Stephanie from this shoot spurred a major turning point in her attitude toward herself. It was proof that her body was not merely acceptable—it was also beautiful.

Survivors of mastectomy, on seeing Venus, told Stephanie that they never imagined they could see themselves as beautiful. "One woman, who also had bilateral mastectomies, had never seen another body like hers," Stephanie wrote to a friend in 2000. Venus caused a stir wherever it went. In planning for a story about the photodocumentary in the Sunday arts magazine in 1996, the feature editor for the *Pittsburgh Post-Gazette* hesitated to run Venus. It was, after all, a picture of a topless woman, and "family" newspapers customarily do not run pictures of topless women. Ironically, he ultimately decided that while the paper's policy prevented him from printing a picture of a woman with breasts, he could indeed run Venus, because there was nothing recognizable as breasts in this image, only twisting scars where breasts should be. These scars, then, artifacts of illness, destruction, pain, and the threat of death, were "appropriate," where whole breasts—signifiers of health, procreation, pleasure, life—were unprintable.

"I can't imagine what it must be like to be a single woman and not have breasts. Our society is so breast-focused," says Stephanie's mother, Barbara. "I think Steph wanted to say to women: 'You can be whole, you can be attractive without breasts.'"

If there were one image in this book that could resensitize physicians, who are trained to objectify the human body—to look at the body's parts instead of the whole—and are thus sometimes desensitized to the effects of their work on the body, it might be Venus. Carty, for one, went to the first exhibition, in 1996, at the Silver Eye Gallery in Pittsburgh. "It blew me away that I had been the surgeon of that beautiful torso that was being photographed in the art mode," she says, shaking her head in astonishment. "I had tried really hard the day of her surgery to have a good cosmetic result, but I didn't know it could be considered *art*. I was very proud that I crafted that with my hands. And it didn't dawn on me that I could do something that beautiful—something that could be considered art by someone else. I didn't consider it art, but Stephanie did."

What had Carty considered it?

"I had considered it a nice outcome," she replies. "And that she could confront losing her breasts and how she felt about it and come to some

good feeling about her body, good enough to show it to everyone, was really an eye-opener for me."

᠅

Brodsky says she strove also to document the human capacity for joy within times of grief. "I want the photographs also to be sunny," she says. "Stephanie would radiate. Many of the hat photographs capture that." They had completed several sessions of photographs when Stephanie showed the work prints to friends, who pointed out that they were too serious; they didn't capture Stephanie's levity, which was a significant aspect of her personality.

"We were always thinking about that," Brodsky says. "There was the very deep sadness, the tragedy of her life, really. But the sparkle was important, too.

"There's a certain level of beauty" in these images, says Brodsky. "Not in the decorative sense. Beauty in that they have meaning and in that they're expressive. I want them to have many levels of meaning. I want you to be able to look at these photographs, some of them for a very long time, and have them still have meaning for you." When the viewer is able to absorb the photograph sufficiently, then "the photograph becomes a metaphor," Brodsky says. "It makes you feel for life—the complexity and difficulty of life. It takes you somewhere else."

᠅

Those who knew her said Stephanie hoped that the photodocumentary— the video, the book—would make her famous. "She did foresee gaining celebrity and immortality through the project," Brodsky says. Stephanie wanted to contribute her own words to the photographs in order to "reach a broader audience," says Barbara Byram. "I know she felt like access to the photographs would be limited unless they were produced in a format other than a gallery exhibition. An exhibition could reach only a few people, while a book could potentially reach thousands."

"She liked being a celebrity. It was surprising—you'd think she was withdrawn, but she wanted to get the message out," says Mike Byram, who watched her speak to crowds and television crews at one Race for the Cure. "Her purpose was to let people know cancer could not stop her life. It was a good way for her to express that there is living to be done while you have cancer. Doing this made her feel she could get well again."

Stephanie's "message," as her father refers to it, comes down to several simple truths: *Live the best you know how. Live while you have time. Slow down. Indulge in forgiveness and gratitude. Enjoy life's abundance.* These ideas are not really all that unique. Many, if not most, cancer patients come to these very insights, though Stephanie's own focus was on breast cancer. "Personally, I feel a tremendous bond with other men and women who have survived the breast cancer experience," she wrote in 2000. "It is a terrifying, lonely, sometimes shameful experience to look and feel so different, to wear the unmistakable beacons of cancer that invite total strangers to ask, 'How much longer will you be in treatment?' With many women who have had cancer, we exchange a glance and we suddenly skip all the formalities and get to the realities: relishing today, relinquishing control, carefully budgeting our time and energy, and, most importantly, loving and laughing.

"Despite this pride," she continued, "the word 'survivor' grates on my nerves. We all live with our various misfortunes, having AIDS or osteoporosis, living without health insurance, being in bad marriages or raising difficult children. We are all survivors. Why should breast cancer be any different?"

The candor and spare elegance she and Brodsky have managed here give the "message" simple strength. In that way, this project is less about breast cancer, being sick, and dying than it is about life—its impulses, joys, and difficulties, and the human struggle to experience these states fully in the ever-changing window frame of the present moment.

In talking about the images she made of Stephanie, Brodsky paraphrases Roland Barthes, from *Camera Lucida.* "He says that in a photograph, I am four things at the same time: the one I think I am, the one I want others to think I am, the one the photographer thinks I am, and the one the photographer uses to exhibit her art." Then what was Stephanie? She was herself, the struggling cancer patient. She was also very conscious of being "the one she wanted others to think she was": being that strong, brave person in front of the camera enabled her to be strong and brave for herself. In being the one the photographer thinks she is—beautiful, a work of art—she also became beautiful, a work of art. In consenting to be the one the photographer uses to exhibit her art, Stephanie achieved the kind of staying power she desired. Even now that Stephanie is gone, Brodsky shares these photographs with students and other audiences; the photographs are featured in a video; and now here they appear, reproduced with care on premium coated, acid-free paper.

I asked Carty what she thought breast cancer patients might learn from this project. "Maybe not as much as Stephanie thought they could," she says slowly. "However, I think women who require disfiguring surgery and healing *could* learn a lot from her pride in her body and her acceptance of her appearance. They could learn a lot from her courage in confronting death and dealing with her prognosis, which she did over and over again." The photodocumentary, then, is not only for breast cancer patients; it is for anyone seeking a willingness to live fully, openly, and with rigorous honesty. Submitting to the lens on a regular basis helped Stephanie achieve a high level of openness about her life and its changes. If, as Brodsky suggests, the photograph enables the viewer to "feel for the complexity and difficulty of life," and to be taken "somewhere else," then certainly this was true for Stephanie herself—the second viewer, after Brodsky, of each of these images. And it can be true, in turn, for each viewer, whether a breast cancer patient or not.

The Optimists' Daughter: Family and The Entourage

Everyone who knew Stephanie before cancer agrees that she underwent a personality change that transformed her from a largely self-reliant introvert into an extrovert who had no qualms about asking others for help. Not surprisingly, the first people Stephanie reached out to when she found out she had cancer were her parents, Barbara and Mike Byram. Stephanie had always enjoyed a very positive and supportive relationship with her parents, and to renew her physical and emotional strength, she often visited them and the place where she had spent so much time as a child, in Spokane and in the Cascade Mountains of Washington state.

Mike—a civil engineer whose own father was a logger in the Washington woods—is a native of Twisp, a village of less than one thousand souls in the Methow River Valley, about fifty miles from the Saskatchewan border and twenty miles from North Cascades National Park, Glacier Peak Wilderness National Forest, Pasayten Wilderness, and the Colville Indian Reservation. These wild, beautiful places and the wildlife they supported made up the landscape imprinted on Stephanie's awareness from earliest memory. Barbara and Mike Byram were only twenty when Stephanie was born; Staci followed four years later. They often took the girls hiking, fishing, and camping, and it was to the mountains and streams—or, in inclement weather, into a book—that Stephanie learned to escape when anything bothered her.

During the course of her cancer, Stephanie often retreated to the Pacific Northwest. In 1998, after finishing her Ph.D. in social and decision sciences, she returned to Washington, to Battelle Research Laboratories, where she had worked before coming to Pittsburgh. Living in Seattle, she was offered a faculty position at the University of Washington. But the cancer recurred in late 1998, and she turned the job down. Anticipating frequent visits to Washington, however, she found Dr. Henry Kaplan, a Seattle oncologist with whom she formed a trusting relationship. Despite the fact that she returned to Pittsburgh within less than a year to get married and to take a postdoctoral fellowship at Carnegie Mellon University, she continued to consult with Kaplan through the rest of her life. She did not consider Pittsburgh "home." In the videotaped interview of 2000, she talks frankly about how she plans to die in Washington. "I don't want to die in Pittsburgh. I want to go home," she says evenly, with a level gaze at the interviewer. "That means when things get bad, Garth and I will be moving temporarily back to Washington. I have a doctor there who I love and who will help me navigate the end of life."

"Steph always said the outdoors and particularly the mountains made her feel alive," Barbara says. "She always felt a connection with the Pacific Northwest. She always talked about how much stronger she felt when she came home." When Stephanie couldn't get back to Washington, her parents often came to her.

Barbara and Mike feel and think so differently about Stephanie that they requested to be interviewed separately for this essay. Mike, as Stephanie well knew, blames himself for causing Stephanie's cancer: though none of Barbara's relatives have had the disease, cancer has cropped up frequently on Mike's side. His mother and her sisters all died of breast cancer. A soft-spoken man with a gentle manner, Mike sank into a depression when his daughter was diagnosed. Stephanie once "interviewed" her parents about her disease and their family's methods of coping with it. "What's your worst fear?" she asked her father.

"You die," Mike said.

"But we all die," Stephanie said.

"But, for you, sooner than you should," Mike replied. "You have a great education, a super personality, you don't know the limits as far as thought, creativity, being able to contribute something to society, and I think it's grossly unfair that you should die without being able to realize it. You shouldn't have to die from cancer."

"It seems you are saying cancer is a moral disease of good and bad, or right and wrong, that there's a justice in who is afflicted," Stephanie commented.

"She was the perfect child," he tells me. When I ask him what he means by "perfect," he says, "Everything she would do, she was successful at. In school, she played basketball, volleyball, baseball. She skied. She didn't have speed, but she had tremendous endurance. She was one of the most coachable people I've ever seen." It is clear, however, that by "perfect" he means more than her outward successes. Later he says, more significantly, "She was so in control of herself that I never worried about her needing help with anything."

"She was of pioneer stock—she had that stoicism. She was not the disclosing kind; Stephanie did not cry with people very often. She didn't have much rage or anger," says her husband, Garth Gibson. Her mother, Barbara, says, "I don't think Steph was ever a pessimist." Optimism seems to be the core personality trait that carried Stephanie through trial after trial. Stephanie displayed the three primary beliefs of an optimist: a belief that her problems were not her fault, a sense that her problems would not last forever, and the conviction that she could prevent problems from undermining her entire life. "She acquired her optimism," says Mike. "My father and his father were of the firm belief that anytime you got sick, you just got better—that's all there was to it. She was quiet before her diagnosis; after, she just made up her mind to become involved in as many activities as possible."

Barbara and Mike appear to be the sort of parents who allow their children to teach them, and who work to recognize and nurture their children's character traits. "Staci could make people laugh," Mike says. "Staci has friends today that Stephanie never had, because Staci was always more spontaneous. Staci wears her emotions on her sleeve." I ask him whether Staci had trouble growing up with an older sister who was so good at everything she did, so capable, so emotionally contained. So "perfect." "Yes," Mike says, and he leaves it at that. Then he adds, "Everything Stephanie did was thought out. She was a good thinker and rationalist, and she learned to overcome her shortcomings by applying herself."

Stephanie would often close the door on emotional intimacy, he says, and in that way she may have taken after her father. "When we would ask her, 'How are you and Garth doing?' she would always answer

noncommittally: 'Oh, Garth's great.' She protected her emotions. She always thought before she acted. She was the opposite of her sister that way. To me, it was fine. It bothered Barbara sometimes. Barbara sometimes felt she was being excluded. She wanted to know everything about Stephanie's illness."

Clearly, Barbara and Stephanie were always close, in the way mothers and daughters can be. The cancer served only to bring them even closer. "As an adult, I never expected to need my mom as intensely as when I was treated for breast cancer," Stephanie writes next to the image of her and Barbara. "Although she lives two thousand miles away, Mom has since transformed into my guardian angel, her voice close to my soul. Her presence is with me every day."

Each time she was faced with a recurrence, Stephanie discussed her treatment options with her parents and took in their responses, though Barbara says Stephanie always made her own choices. "Steph made a lot of treatment decisions that I wouldn't have agreed with," Barbara says. "Sometimes she would delay treatments around whatever else was going on in her life. If she had a trip planned, she would weigh the risks of delaying treatment against the value the trip had for her, and she would sometimes delay treatment until she got back." In 1996, when cancer was detected in five of thirteen lymph nodes removed from her left armpit, Stephanie endured four months of chemotherapy, then refused the recommended follow-up radiation therapy. This decision was one of the only times in any of her physicians' dictations that Stephanie's equanimity is described as upset, with Jacobs, her Pittsburgh oncologist, noting, "She seems quite distressed to the point that it is interfering with her daily activities." She was arguing with her mother about refusing this treatment.

"We had a big disagreement about radiation," Barbara says. "She talked to the radiation oncologist, and made the decision that the data didn't support having the treatment. I would tell her in very strong language that I disagreed, and she would still do what she wanted. She'd say, 'I hear you, Mom, but this is what I'm going to do.' One of her doctors told me, 'You have to remember that this is Stephanie's disease.'"

In her interview with her parents, Stephanie asked her mother, "You had to help me navigate cancer while living far away. What was that like?"

"I think it's more frightening when we're apart," Barbara said. "When I'm around you I feel less scared. Maybe part of it is that I feel more

helpful when you're closer. When you're able to see and touch the other person, it gets rid of the fear."

Barbara sometimes weeps while speaking about Stephanie. The loss of her daughter, only nine months past at the time of my talk with her, is still very raw. She mentions that Stephanie was bitten in the face by a dog when she was four, and had to have thirty-seven stitches; that, at age eight, she was hit in the eye with a bat and spent several days in the hospital on her back. Later, her retinas detached and laser surgery was able to repair only one; in the other, a silicone band was placed around the eyeball to hold the retina in place.

"I sometimes think the universe was presenting her with challenge after challenge to see what would break her," Barbara says. "But it never did break her. She never quit loving life."

౩

I ask Barbara whether she was surprised that Stephanie chose to get married. "I was not surprised that she got married," she says. "I was surprised that Garth wanted to get married under the circumstances."

"Stephanie filled in and rounded out my life in a beneficial way," Garth Gibson tells me, his eyes reddening. "She pulled me out of a very narrow world."

Gibson, forty-one, is a self-described workaholic. He teaches computer science at Carnegie Mellon University, and in his "spare" time he runs his own thriving network data storage business headquartered in California, with offices in Houston and Pittsburgh. He met Stephanie in 1995 at the wedding of one of his employees. They had three or four dates before cancer recurred in Stephanie's armpit. "Our relationship was always bound up with dealing with cancer and facing mortality," Gibson says. Gibson's mother, grandmother, and brother all had cancer, and he felt he hadn't been present enough to help them. Helping Stephanie, he hoped, would make up for his past absence.

But *marriage?* "I tend to be attracted to people who need me," he says. "I certainly appreciated the intensity of her attraction."

If Stephanie was attracted to him early on, she was also honest to a fault: when the cancer recurred, she put him on hold and gave him the chance to opt out.

"Stephanie came to me and said, 'Cancer's going to occupy my time for a while. I hope you're willing to be patient, and make no demands on the relationship,'" he said in the videotaped interview in 2000. "So I

became one of The Entourage. Stephanie had an entourage of people who paid daily attention, came around. We had a lot of fun, we were quite a gang of people that hung around at that time."

About nine months after taking a break, Stephanie came back to Gibson and told him she wanted to keep trying. They continued to see each other even after she returned to Washington. "Idealistically, Stephanie was packing in a whole life. She wanted to go through as many of the stages of life as she could," Gibson says. "But practically, cancer is a full-time job. You have to think about doctors, treatments, insurance, and everything else. She had been doing all of this alone." Gibson proposed marriage in 1998 on a visit with Stephanie to a Twisp cattle ranch. "It was too emotional," Gibson says, "there was too much at stake, and Stephanie said she would think about it." She consented a few weeks later when they were back in Pittsburgh: in repeating his proposal, he noted marriage's more practical benefits, including additional insurance options and a committed companion to help her make serious decisions.

They had planned a fall 1999 wedding, but in April cancer was found in her pelvis and spine. Bone metastases are always incurable, though they can be managed for months, sometimes years. For the first time, Stephanie realized—albeit slowly—that her cancer would not be cured. She and Gibson moved the wedding up to June. They were married by the pastor of the Unitarian Universalist church near the university: he gladly married them in a hurry when other clerics turned them away. Later, at Stephanie's behest, they became members of the congregation, more for Garth's benefit than her own. "Stephanie knew my compulsive work habits, and she wanted to make sure I had friends outside of work," Gibson says.

For when she was gone, he meant.

༄

They settled down in a 1920s house they purchased shortly after they married. Stephanie thought of this house as her gift to her husband, and she set out to renovate it as her primary material bequest to him, hiring an architect to overhaul the kitchen and choose the colors, and planning the garden herself. Work, school, dinners together, reading, listening to music, taking walks: it was a quiet, ordinary life.

One of the duties Gibson assumed for his wife was to keep their life quiet and ordinary, serving as a buffer against the outside world, even to some degree against The Entourage. As a proactive measure, Gibson

devised the "StephTrackers" e-mail list, which they posted to The Entourage during the last two years of her life. He updated them in May 1999 about the recurrence to her bones. After outlining her condition and her treatment options, which he says, "are palliative, not curative," he urges her friends to keep in touch. "Feel free to send Stephanie notes or cards," he concludes. "Please refrain from calling to express sympathy—it is very draining on Stephanie to respond to well-meant sympathy." It was draining perhaps because, as Gibson told me, "Stephanie engaged with people with 100 percent of her attention. She showed a willingness to engage, especially with new people. Many people, close friends, would say they wanted more time with her. She connected intensely with new people. She might not see me, but she was gonna see these people."

As the cancer inexorably spread for the last time, her old friends wanted to have more contact with her. Because Stephanie had always been so open with her friends in allowing them to participate in the navigation of her illness, they wanted to be open with her about how they felt, now that they were preparing to lose her. Grief actually begins *before* a loved one dies. It is one of many natural responses to the advent of a loved one's death; the name psychologists give it is "anticipatory grief." Stephanie wanted the company of friends in her journey toward the end of her life, but she never wanted to talk about death or grief; she wanted only what she called "positivity." Gibson served as a buffer here, too, educating her friends about the progress of her illness and asking them, for Stephanie's sake, to keep their spirits up when they had contact with her.

"One of the hardest things she had to deal with was helping people with their grief that she was going to die," Gibson says. "People wanted to hear, 'It's better now, she's cured' or, 'It's worse now, she's dying immediately.' They couldn't seem to dwell in that space of uncertainty. Only the people she'd spent a lot of time with could understand that there would be a long decline, that it would be a lengthy process. The others—well, they just couldn't see her as being on death's door when she's climbing mountains in Peru."

To the Lost City, the Temple of the Sun, and Beyond: Embracing Change

Peru was just one of a number of exotic destinations Stephanie visited after she was diagnosed with cancer. In 1996, she and Barbara took a trip from Seattle to London to Tibet, Thailand, the Philippines, and Hawaii.

Later that year, Stephanie went on an African safari; with Gibson, her parents, and her sister, she passed the turn of the millennium on Australia's Great Barrier Reef. The April before she died, she set out to tour the western states with her father, stopping at Grand Canyon and Canyon de Chelly, where her father had organized a private spiritual tour of sacred sites led by a medicine man. Even when her travel was not extended or exotic, Stephanie liked to move in style, booking spa days with her mother and spending Seattle weekends with her husband, not in family digs or on friends' futons, but in fancy hotels. A StephTrackers e-mail from Gibson notes they'd just spent a weekend in Seattle "staying at the Sorrento Hotel (old building elegance and grace, mucho service and cost)." The Sorrento is Seattle's oldest operating luxury hotel, where room rates range from two hundred to seventeen hundred dollars per night and maids turn down the bedclothes, inserting hot water bottles on chilly evenings. Barbara says Stephanie started out wanting to travel like a native, but in Nepal "I told her not to drink the water. Steph had been all over the world, but she had never been to a Third World country. The first night, she goes to a native shop and has tea and ends up sick with dysentery." This was just months after she had finished treatment for her first recurrence. "Steph just didn't consider herself sick," Barbara says. "This bout with dysentery taught her that sometimes it's more prudent to be an upscale traveler."

Stephanie and Gibson had been planning the trip to Peru even before they planned their wedding. They had been planning for it even before the bone metastases were discovered. Stephanie had always been sportive, and though she dismissed herself in her writings as "a fairly athletic woman (recreationally)," she was competitive and diligent about choosing her challenges and recording her achievements, which gave her the satisfaction that triumph gives an athlete. Less than a year after her first diagnosis, she had seriously taken on the goal of running every single Race for the Cure in the U.S., which she often referred to as a "quest"; she completed thirty during a time when there were only twice that many being held. She recorded each of her scores and listed her personal bests and the places she took among competing breast cancer survivors. To call herself a "recreational" athlete was unduly modest, or simply un-realistic. Athleticism was one of many high expectations Stephanie placed upon herself. By putting herself in these extremely challenging positions, and by succeeding at them and then joyfully sharing her success via e-mail with her Entourage (itself a term reserved for athletes and other

celebrities), she could feel almost as though she were in a class by herself. It reinforced her desire to be special. She needed to be very special indeed if she were going to beat the cancer.

To train for Peru, she and Gibson decided to climb the stairs of the University of Pittsburgh's thirty-six-story Cathedral of Learning—a strenuous training regimen usually taken on only by competitive athletes. Serious mountain climbers sometimes meet to climb the Cathedral steps, pack on back and staff in hand. "Twice each visit. Two visits a week," Gibson wrote to The Entourage. "So when Steph's back started to bother her, we suspected excessive stair climbing. However, the pain did not go away." An MRI showed cancer had settled in five vertebrae and in the left side of her pelvis. The big question raised by these incurable recurrences was not whether they would prevent Stephanie and Gibson from getting married, or how long Stephanie would live, but whether the trip to the Andes was still a realistic possibility—a mark of how important this journey had become to Stephanie. They had planned to hike the Inca Trail to Machu Picchu, the Lost City of the Incas. After the MRI she went home to Seattle and saw Kaplan; both her oncologists were supportive, Kaplan especially so, of her unconventional plans to travel while managing incurable—and possibly quite painful—metastatic disease. Since Stephanie had no symptoms other than back pain, Kaplan advised delaying chemotherapy until she returned from Peru: "I certainly agree with the radiation, though I don't know why we need to do a rapid course," he dictated to the record. "I'd hold off on chemo for the moment and restage her in terms of the speed of her disease when she gets back from Peru." Radiation to the spine and pelvis before the trip would control her pain.

Her mind was entirely focused on making this hike. "The journey filled me with trepidation. Not only was it a long hike—thirty-five miles —but it was also at altitudes new to our lowland bodies," Stephanie recalled in 2000. "My health felt fragile to me; during radiation treatments only weeks before, a nurse emphasized the care I needed to take with my cancer-ridden bones, explaining that I could 'slip, even on a pebble, and get a hairline bone fracture or fall and break a hip or vertebra.'"

As a precaution, Jacobs gave her prophylactic Cipro, the antibiotic used for heavy-duty infections such as anthrax. She obtained compression sleeves to reduce the possibility, in the Andes' thin atmosphere, of swelling where her lymph nodes had been removed; enough prescription-strength Ibuprofen to permit continuous dosing; and a list of physicians in

Peru. "Stephanie is aware of the extent of her disease," Jacobs dictated on June 2, 1999. "She is still adamant about proceeding with her marriage plans on June 18 and then trying to go to Peru."

She and Gibson were married. "We desperately hung onto those moments of joy, temporarily forgetting the cloud of illness looming in our future," she wrote in 2000.

ॐ

Three days later they flew to Cuzco.

"Garth and I gave ourselves every advantage," she noted. "We selected a reputable tour company to help us navigate the language, culture, lodging, transportation and daily logistics of food, water, and toilets. Still, as the bus pulled up to the trailhead, I felt ready to ride right back to Cuzco." Gibson, ever her rock, told her that he'd be with her every step of the way, carrying her if necessary. Still, she was required to sign a release agreeing that, if she fell, there would be no search and rescue.

It took them five days to walk through three mountain passes and into Machu Picchu. The second day they crept four thousand vertical feet on a twelve-mile path. "Despite taking it slowly, I never felt so relieved when I made it to the top," she later wrote. "The crew foreman greeted me at a rise about half a mile from the camp. The concern, pride, and relief in his face suddenly melted my resolve and I burst into tears. I walked into camp, laughing and crying among a herd of llamas and alpacas . . . astonished at my incredible body."

The third day, as the sun set behind the Andes, she and Gibson exchanged heart-shaped rocks they'd found on the trail in a private ceremony of commitment. "Despite my exhaustion, I began to feel renewed and revitalized," she wrote.

The fourth day, the crew foreman, who was a shaman, held a special ceremony for them. "Our last night . . . was deeply spiritual to many of us," she wrote. The fifth day, they reached the Temple of the Sun. "No other word than spectacular describes the place and our feeling of accomplishment for having finished the long, challenging hike," she wrote.

"In making the trip I realized that I cannot know the limits of my abilities until I test them. The warnings from the nurses and doctors, and the tentative signals from my own body, nearly frightened me away from trying. True, I must trust my body and my instincts in knowing when I have gone too far or pushed too hard. Then, I must forgive myself, take

lots of drugs, and let myself recover. But unless I take the risk, I will never know how high I can fly."

The history of pilgrimage is richly populated with individuals who, facing the possibility of death, have cast money, time, and practicality to the wind. Clearly, Stephanie was determined to complete this journey for the spiritual healing it might provide, not just for the physical challenge—although that was certainly a part of it. She had always relished investing herself in physical challenges and coming out the other side with the reward of conquest; this time, the equal if not greater reward was spiritual reassurance. She had arrived at the Temple of the Sun and worshipped there with her life companion. She came back ready to settle her spirit for the last time.

కు

"I'm not sure in Buddhist terms what would be the equivalent of what you call 'spiritual,'" says Catherine Gammon, a student in Zen Buddhism in California. "Buddhist practice emphasizes awareness, beginning with self-awareness. In that sense, what Stephanie called 'mental reconstruction' fits the awareness we cultivate in Buddhist practice."

Around the time she began training for Peru, Stephanie also began a meditation practice at Stillpoint, a Zen center in Pittsburgh. It was at Stillpoint that Gammon, a novelist and former associate professor of English at the University of Pittsburgh, met Stephanie. Gammon came to know Stephanie through practicing with her at Stillpoint and through spending time with her in the last several months of her life.

"Before I really knew her, I think she still had the attitude that said, 'Through will and determination and love, I can keep this thing from killing me,'" Gammon says. A few days before she died, Stephanie gave Gammon a copy of her videocassette, which showcases the photographs and some of Stephanie's captions. "The video made me sad," Gammon says. "By the time I saw the video, she was about to die. The video was still about, 'I can conquer this through my will and intention and determination.' By the time I knew her, she was just living with her dying. She was accepting the fact of her dying. She was living moment to moment. She was radiant."

After returning from Peru, Stephanie again started chemotherapy, which her physicians told her would last through the rest of her life, however long that might be. No one guessed that it would be nearly two years. By August 1999, cancer had been found in her liver, an incurable

event that indicates the cancer is spreading into major organ systems. Since the liver filters blood and distributes it to the entire body, cancer in the liver is likely to spread to many other distant sites. For roughly the next year, the liver and bone tumors were controlled and even temporarily reduced in size using various chemotherapeutic agents.

In August 2000, however, Stephanie began to have headaches, "like an ice pick stabbing into my temple, every time I would bend over and then straighten again (getting out of bed, tying my shoes, picking up the cat)," she wrote to the StephTrackers. "I tried decongestants (ineffective) and anti-inflammatories (very effective), figuring it was a sinus infection, allergies, stress, migraines, or just plain bad luck. Oh, the power of denial. It turns out that these kinds of symptoms are classic for pressure on the brain—that is, there is something that is causing brain swelling." An MRI of the head showed four tumors, including one on the cranial nerve that controls balance, which made her dizzy. "Because I've been asymptomatic in the past, we have no idea how long the tumors have been there or how fast they are growing," she wrote.

Metastases to the brain are generally considered to be a preterminal event. Untreated, the patient can die in a matter of days or weeks. Yet, at the same time, outwardly, the patient can appear quite well. Kaplan, her Seattle physician, kept noting how well she looked. "She really looks great," he records on one 2000 visit. On another, "She really looks quite good." As though he mistrusted his senses: *She can't be dying; she really looks good. Really really.*

To reduce the pressure inside her skull, Jacobs scheduled her for whole-head radiation followed by stereotactic radiosurgery, sometimes called the "gamma knife," which uses two hundred low-strength beams; each beam is weak, but when two hundred converge on a single area, their power concentrates. Fortunately, Pittsburgh has a gamma knife center, so Stephanie did not need to travel far to receive treatment. After her whole head was radiated twenty times, Stephanie went under the gamma knife on a November 2000 morning; by afternoon, she was at home, working in her garden.

And going to Stillpoint to sit *zazen*.

☞

"There is an intimacy that grows up around sitting in silence," Gammon says. "I think the people in Stillpoint felt intimate with Stephanie. It wasn't about talking." Because of frequent trips back and forth to Seattle,

Stephanie "came and went quite a bit," Gammon says, but when she was in town she made time to sit at Stillpoint.

About a year after beginning her practice, she decided to receive the Zen Buddhist precepts, which would make her a lay practitioner of Buddhism. As part of a group of Stillpoint practitioners receiving precepts with a visiting Zen Buddhist teacher, Stephanie was required to participate in retreats and study groups. In one of these retreats, about two months before she died, she asked the Zen teacher about Buddhist thinking regarding death and afterlife. The teacher quoted a passage from David Chadwick's book about Suzuki Roshi, *To Shine One Corner of the World*: "You will always exist in the universe in some form." "This gave her a great deal of comfort," Gammon says.

As tumors took over her liver and her health began to decline, Stephanie asked Gammon if she would spend time with her—just being with her as she began to live with the imminence of her death. Gammon had recently been present for the death of her own mother. "I think I was the only person Stephanie knew who had literally been present when someone had died," says Gammon, who agreed to do as Stephanie wished. They mostly took walks in a park near Stephanie's home. "I liked being present for her, and I appreciated the generosity of her asking for help."

Stephanie felt strong enough throughout the first part of 2001 to tour the West with her father. "It was in celebration of living," Mike says. "She just wanted to live. She didn't want to hear any prognoses. It had gone to her brain and liver." It was the first extended period they had ever spent alone together. They made a traditional Native American "medicine bundle" for her, using a bowl handmade by a potter friend of the family in New Mexico. Then, the spiritual tour of Canyon de Chelly with the medicine man. "He conducted a healing ceremony for us. He didn't try to say she'd get better. He gave her some herbs for her medicine bundle and told her that her protectors were the Cloud People. The next morning, we saw that it had snowed, and not just a dusting, but six or eight inches on the ground. We saw this as very auspicious: the native peoples consider it a good sign when water comes out of the sky near planting time."

They spent much of their time in silence. As with her new friends at Stillpoint, Stephanie wanted company without words—simple, silent acceptance of her dying.

They took an unexpected detour to Twisp, where Stephanie visited her grandparents. "She came out and said it would be the last time she'd

be there," Mike says. "When we reached Twisp, she turned to me in the car and said, 'Dad, I think my eyes are turning yellow.' Because, you see, her liver was starting to fail. I just told her, 'Yes, I think they are.' I couldn't say anything else. She didn't want to hear the negatives. She didn't want to hear anyone tell her she wasn't going to come out of this. One part of me wanted to say, 'You should start planning for your death.' I wanted to say, 'How can I help you?' But in the end, I didn't say anything.

"There was always the love you wanted to express that you don't because it would admit to her that you know she's dying. This was very, very hard for me. I sometimes wish I'd been more forthright. Some people may need to know that, but Stephanie didn't want to think about death. Sometimes she'd get a little angry with Barbara when Barbara showed her feelings about it."

Stephanie returned from this trip in the third week of May, still able to walk, still able to eat. If she'd known she was so close to death, her parents say, she probably would not have come back from Washington. "The cancer caught up with her quicker than she thought," Mike says. "I honestly don't think she let herself believe she was so sick. She was not in excruciating pain till the artery broke in her liver, which was the thing that caused her death. She'd recovered so many times that no one ever said, 'It's close to the end.'"

Even in May, Stephanie was still working on preparing to receive the Buddhist precepts. "It may have been a desire for this plain awareness without flinching that drew Stephanie to our practice," Gammon says. "Her determination to receive the precepts said how strongly she felt about her Buddhist practice." The visiting Zen teacher who had known her in retreat chose her Buddhist name posthumously: *Myoshin*, "bright heart" in Japanese. After she died, her friends from Stillpoint stitched her *rakusu*, a small version of the Buddhist robe used in the precepts ceremony. She certainly had wanted to proceed with her study and the ceremony.

However, on June 4, a Monday, Stephanie felt weak enough and in enough pain to plan to return to Washington and to ask her family to inquire about Zen hospice opportunities in Seattle. She did not make it back, though. There was a steady flow of visitors and callers, even after Stephanie entered Shadyside Hospital in Pittsburgh later that week. "My experience of being with her and her family and the way they opened up

her illness to the world was that it was an act of enormous generosity," Gammon says. "That they could allow so many people to support her, to take care of her—most people circle the wagons and don't permit anyone to become involved. Most people don't invite help during grave illness and death. Maybe some people assume it's an imposition."

It happened very quickly: on Thursday she began to throw up blood; her family took her to the hospital, where she was put in intensive care for two days. The tumors had broken the major artery in Stephanie's liver, and blood was pouring into her stomach. With her liver shut down, fluid was collecting in Stephanie's abdomen, causing unbearable pressure and pain. The attending physician said a catheter could be placed in Stephanie's abdomen to drain the fluid, but her family felt this measure would be too invasive. Instead, they asked to take her home. She was given an intravenous Dilaudid drip, her oncologist certified her as appropriate for hospice care, and she was discharged in an apparent coma. In many cases, hearing is the last sense to depart the body; even when a patient appears completely unresponsive, she might be able to hear. So earlier in the day, before she was discharged, Gammon and a fellow Zen student stood beside Stephanie's hospital bed and read her the precepts ceremony she had intended to receive.

Once at her house, the evening of June 9, it is said, she opened her eyes, recognized that she was at the home she shared with her husband, became aware of the familiar sounds and smells, and smiled before she died.

♌

"I feel like I have an angel on my shoulder," Stephanie had told her father the previous summer.

"You mean an imaginary angel?" he asked.

"No, a real angel that talks to me," she told him.

"I agreed with her, rather than telling her it was all in her imagination," he says. *You will always exist in the universe in some form.* Mike believes the "angel" was "the side of her that was saying to herself, 'If there's a chance that you're going to die, then I've got you covered.'"

The day before she entered the hospital, Barbara had sat with her at home. "I was really sad," Barbara says. "I was sitting with her, and she asked me why I was sad. I told her, 'I'm just so sad because you're going away, and I won't be able to see you anymore.' I was in so much pain.

She looked at me and smiled, and said, 'Mom, I'm not going anywhere—I'm having too good a time.' That was just like her."

Stephanie planned it so that she would never be completely gone. She had requested that her ashes be spread in several locations throughout the Methow River Valley: on the summit of Slate Peak; in Eight Mile Valley, filled with Ponderosa pine and long grass, where her medicine bowl and bundle were buried; on the grave sites of her paternal ancestors; on the grave of her maternal grandmother; and on an island in northern Idaho. Barbara and Mike carried out her wishes the summer she died.

So her very body is always and forever in the landscape surrounding Twisp—and thus, from a Buddhist perspective, in the whole earth, even in the whole universe. She exists in many forms, of which this book is just one. I only met Stephanie twice: once at the first showing of her video, a month or so after my mother died of lung cancer; and about a year later at Charlee Brodsky's home, where we happened to cross paths one day, both subjects of Brodsky's lens—images of our bodies could often be seen spread across Brodsky's big walnut dining table. She had less than a year to live then, though no one knew that, but I instantly recognized from caring for my dying mother the previous year the puffiness in Stephanie's jowls that comes with steroid therapy for brain metastases. She asked me to sit next to her at Brodsky's dining table as she leafed through the manuscript she was trying to put together. There was no sharing of news, no "How are you." Small talk falls away at the end of a life: it was obvious that she was ill, and by contrast that we were quite well. Her attention was completely turned toward "The Stephanie Project," as she and Brodsky called it, and she wanted our attention to be only there as well. She lingered over each photograph and caption with pride, and I saw, even knowing her as little as I did, that she needed to believe she was going to be around even when she was no longer around. I sat with her as I had sat with my mother, trying to be present to a great need. I knew, and I think she knew, that she was near the end and probably would not complete the work, but I did not imagine I would be asked to finish what she had started.

Reconstructing her life, I've gained a few lessons from Stephanie's experience. While writing this biography, I've sometimes felt Stephanie's presence in the room with me. As I checked facts, she would tell me, "Make sure you get this right!" Or, as I struggled with a difficult sentence or paragraph, she would urge me, with a smile spreading its "sparkle" across her face, "Slow down. Take a break. Forgive yourself."

Or maybe it's just my imagination. As Mike said he thought the "angel" might have been Stephanie's imagination.

"Stephanie is still driving my life," Gibson says, sitting with a cup of coffee in the gorgeous maroon-painted dining room of the house that Stephanie renovated for him. Stephanie's presence is everywhere there: the cats, who loved her and searched for her for months after her death; the Native American hangings; the photographs; the high, Celtic singing of Loreena McKennitt, one of her favorite musicians. The worn floral chintz couch that she moved from apartment to apartment to house, on which she used to rest, is still in the living room of this gracious home, incongruous beside Gibson's sleek teal leather furniture and black tubular stereo tower. There is more above and below stairs. "I have a basement full of Stephanie videos. I'm speaking at church in a couple of weeks— something I'd never have done before. There is no question that my life has been far more enriched by spending time with Stephanie than it would have been if I hadn't."

A small table, like an altar, stands in a corner of the living room, holding pictures of Stephanie, letters sent by friends after she died, and artifacts from her travels. She had brought many treasures, exotic and ordinary, back for friends, and had instructed many of her own to be given away after her death.

"Most cancer patients don't bring stones back from Peru for you," says Carty. "But then, most doctors don't keep those stones on their kitchen windowsills, as I've done with the stone Stephanie brought me. I still have it sitting right over the kitchen sink."

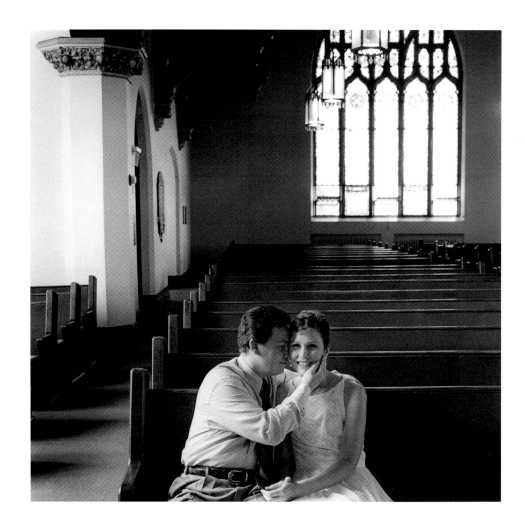

Stephanie and Garth, a year after their marriage, dressed in their wedding clothes and sitting in the First Unitarian Church where they were married. This was Charlee's wedding present to Stephanie and one of the last photos that she made of her.

Acknowledgments

We are indebted to Cynthia Miller, who made this book become a reality; to Jennifer Matesa, who produced a masterful profile of Stephanie; to Deborah Meade, who, with great sensitivity, refined our words; and to Ann Walston, who designed our work into a beautiful book.

Thanks to those family and friends who agreed to be photographed for our book: Barbara, Michael, and Staci Byram, Ann Bostrom, Katie Greeno, Tamara Hayes, Mark Holland, Karen Jenni, Carol Mitnick, Emil Ochotta, Marilyn Quadrel, Roland Schaefer, Casey Traver, Dean Panizzi, Laura Ruetsche, Dean Behrens, and Sally Carty.

Many individuals contributed to and supported our work during its many phases: David Demarest, Michael Fields, Shannon Ford, Lois Fowler, Linda Benedict-Jones, Camilla Griggers, Mary Rawson, Howard Read, Ellen Mazo, Ann Curran, Mary Ellen Gubanic, Frank Caloiero, Mark Knobil, Peter Blume, Peg Furshong, Amanda Ford, Fred Polner, Lee Gutkind, Rob Lefferts, Baruch and Andi Fischhoff, Rutie Kimchi, Dan Boyarski, Andrea Stephany, Barbara Hatfield, Jean Caslin, Marita Holdaway, Laura Vinchesi, Channa McNeil, Jo Leggett, Mark Murphy, Tanya Ozor, Faith McLellan, Jon Wilson, Mary Zubrow, George Loewenstein, Robyn Dawes, Jennifer Lerner, Paul Fischbeck, Cristina Bicchieri, Ned Welch, Julie Downs, Michael Scheier, Roberta Klatzky, Lisa Schwartz, Steven Woloshin, Michele Colon, David Herndon, Ali and Audrey Masalehdan, and Barbara Lazarus.

We also want to thank various organizations: our friends at the Race for the Cure, including Nancy Brinker, for her vision, Ellen Goodman, and Laurie Moser; colleagues at New Balance Athletic Shoe, Inc., who helped Stephanie get started on her Race for the Cure quest, including Joyce Furman and the members of Honorary Team New Balance, Mark Goldstein, Linda McCoy, and Ann McCoskey; Stephanie's colleagues at

Battelle; the community of the Stillpoint Zen Center; and our friends at Dean of Shadyside.

 Much appreciation to Carnegie Mellon University and the Pennsylvania Council on the Arts for trusting our vision and funding us at various stages of our work.

 Lastly, we want to acknowledge our families, who always support us: Mark, Gillian, and Allyn Kamlet; Barbara, Michael, and Staci Byram; Garth, Ron, and Mary Gibson.

Charlee Brodsky, Stephanie Byram

ॐ

More than most people facing the end of life, Stephanie shared her experience. I would like to thank the many people who, in sharing of themselves, made the writing of Stephanie Byram's biography not only possible, but also a rich and rewarding experience: Cynthia Miller, for sharing her confidence and enthusiasm, and for inviting me to be a part of this book; Barbara and Mike Byram, for their generosity in securing and sharing Stephanie's medical records, and for their willingness to speak candidly and warmly with a total stranger about their elder daughter's life and death; Garth Gibson, for graciously hosting our interview at the home he shared with Stephanie, and for providing a wealth of written material from her files; Dr. Sally Carty, for sharing her experience with this "most intelligent patient" and for reading the manuscript for technical accuracy; Mark Holland, for the background he shared about Stephanie's early illness; Catherine Gammon, for sharing insight about Stephanie's last months and Buddhist practice; Tammy Laughlin at WTAE-TV in Pittsburgh, for sharing her 2000 videotaped interview of Stephanie; Charlee Brodsky, whose work I respect, for once again sharing publication space with me; and Nicholas Coles, for always sharing his love of language, his respect for women, and his open embrace of life.

Jennifer Matesa